BETWEEN TRANSCENDENCE AND BRUTALITY

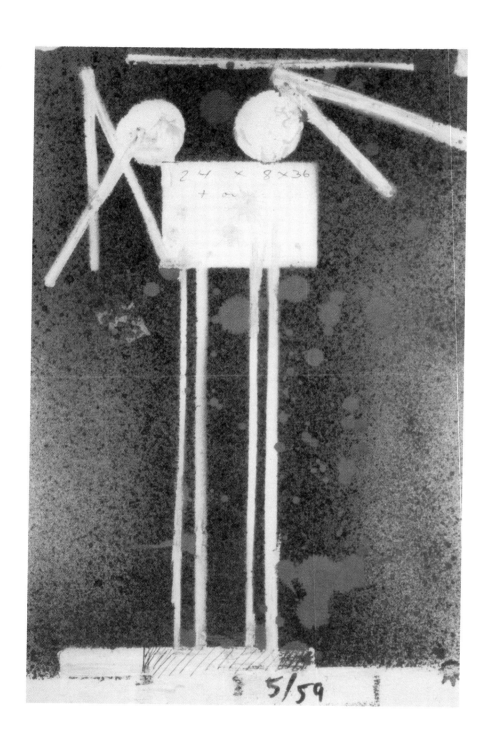

David Smith, *Untitled*, 1959. CAT. 139

BETWEEN TRANSCENDENCE AND BRUTALITY

AMERICAN SCULPTURAL DRAWINGS FROM THE 1940S AND 1950S

Louise Bourgeois

Dorothy Dehner

Herbert Ferber

Seymour Lipton

Isamu Noguchi

Theodore Roszak

David Smith

Organized by
Tampa Museum of Art

Douglas Dreishpoon
Curator

Tampa Museum of Art
600 North Ashley Drive
Tampa, Florida 33602

EXHIBITION ITINERARY

Tampa Museum of Art
Tampa, Florida
January 30–April 3, 1994

Arkansas Arts Center
Little Rock, Arkansas
July 15–September 1, 1994

The Parrish Art Museum
Southampton, New York
September 24–November 7, 1994

LENDERS TO THE EXHIBITION

Louise Bourgeois

John E. Cheim

Dorothy Dehner

Richard L. Eagan Fine Arts, New York

Edith Ferber

M. Anthony Fisher

Terese and Alvin Lane

Isamu Noguchi Foundation, Inc.

Knoedler & Company, New York

Robert Miller Gallery, New York

James and Barbara Palmer

Private Collections

Candida and Rebecca Smith

Theodore Roszak Estate

CONTENTS

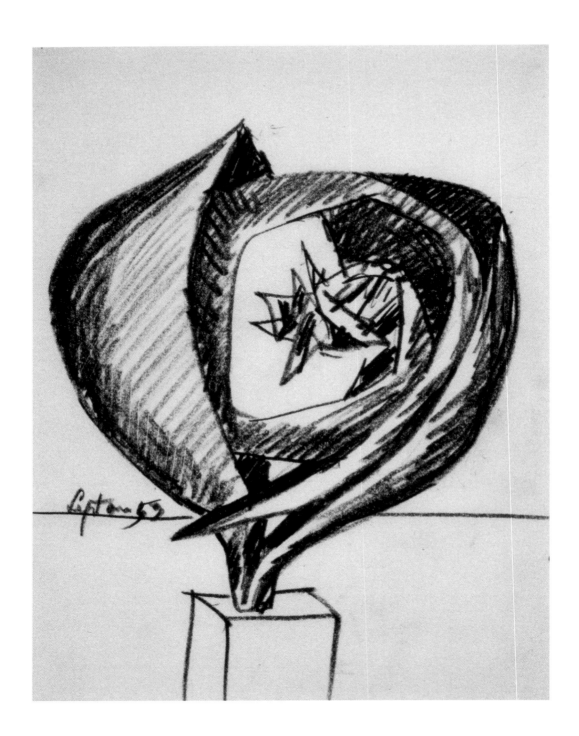

Seymour Lipton, *Study for "Sanctuary,"* 1953. CAT. 79

FOREWORD

Between Transcendence and Brutality, the exhibition and accompanying catalogue, culminates Dr. Douglas Dreishpoon's research of the past year and a half and marks his first major exhibition at the Tampa Museum of Art. It is a harbinger of good fortune for the future of the Museum's exhibition and scholarly publication programs. Doug's academic background and bias toward 20th-century drawings were important attributes that influenced his appointment as the Museum's first curator of contemporary art. With this survey exhibition of American postwar drawings, it is Doug's desire to expand the permanent collection in this direction as well as follow up this superb exhibition with works from the succeeding two decades.

The Museum is pleased that this inaugural exhibition will travel to two other esteemed institutions. I want to thank Townsend Wolfe, Director, and Ruth Pasquine, Curator, at the Arkansas Arts Center, as well as Trudy C. Kramer, Director, and Donna De Salvo, Robert Lehman Curator, at The Parrish Art Museum, for participating in this project.

R. Andrew Maass
Director

ACKNOWLEDGMENTS

Many individuals made the realization of *Between Transcendence and Brutality* possible. I want to thank Louise Bourgeois and Dorothy Dehner for their participation; Nathan Kernan at Robert Miller Gallery and Richard L. Eagan for facilitating my numerous requests regarding both artists; Edith Ferber, Sara Jane Roszak, and Candida Smith for granting me access to material in the estates of Herbert Ferber, Theodore Roszak, and David Smith; Bruce Altshuler, Director of The Isamu Noguchi Foundation, for allowing me to select work from their collection; Bonnie Rychlak, Registrar, and Amy Hau for making arrangements to have many of Noguchi's drawings photographed; John Driscoll, Director of the Babcock Galleries, for introducing me to James and Barbara Palmer, who graciously lent a suite of drawings and several sculptures by Seymour Lipton; Lori A. Verderame, Registrar for the Palmer Collection, for promptly answering several questions as they came up; John E. Cheim, M. Anthony Fisher, and Alvin and Terese Lane for lending works to the exhibition.

Marella Consolini, at Knoedler & Company, accommodated my request for small-scale sculptures by Herbert Ferber; Diana Bulman, Archivist at Robert Miller Gallery, assembled reproductions of Louise Bourgeois drawings.

At the Archives of American Art, Cathy Stover, David Dearinger, and Arleen Pancza-Graham made my whirlwind research excursions to New York during the past year that much more productive.

8

Charlotta Kotik, Curator at The Brooklyn Museum of Art, provided me with a reproduction of David Smith's *The Hero*, as seen from the back. Such an unlikely request, no small undertaking as it turned out, was effectively carried out by Shelley Bogen.

Given the exhibition's postwar focus, I felt its catalogue should include more comprehensive chronologies for each artist. These were reprinted from various monographs and exhibition catalogues. I want to acknowledge Dore Ashton, Joan M. Marter, Phyllis Tuchman, Karen Wilkin, and Deborah Wye for granting me permission to reprint their text.

Several Tampa Museum of Art staff members deserve special thanks. Bob Hellier not only designed and supervised the production of the catalogue but led the installation team of Tom Kettner, Kevin Horning and Bob Huntress. Tom Kettner also photographed most of the works for this catalogue and, together with Mark Feingold, executed the framing. Registrar Kay Morris made order out of what could have been chaos by orchestrating administrative details while Diane Broderick assisted with all aspects of catalogue text preparation.

I am also grateful to R. Andrew Maass, who, as Director, allowed me the flexibility of time to prepare this exhibition and the budget to accomplish it in its entirety. And finally, I thank Ida Dupont for her constant support and patience.

D.D.

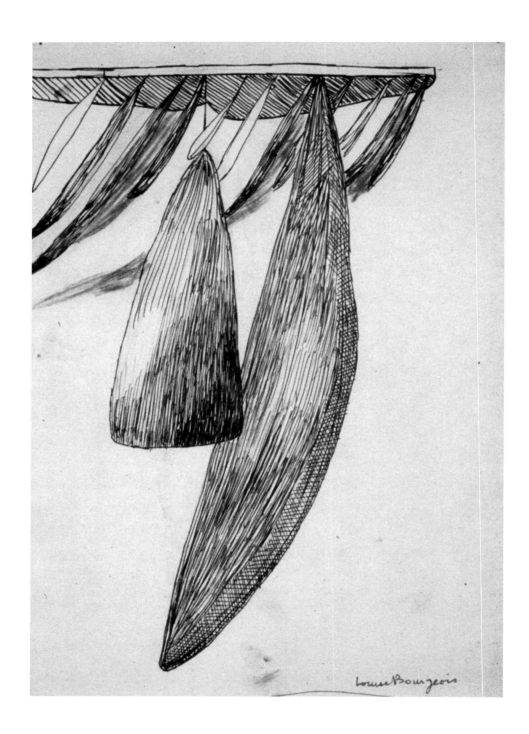

Louise Bourgeois, *Untitled*, 1947. CAT. 7

INTRODUCTION

In the larger history of American sculpture, the 1940s and 1950s were crucial years, a time of transition and transformation. Postwar American sculpture developed out of a conflation of sources—Surrealism, Constructivism, primitivism, and myth—and sculptors' drawings lay bare themes that distinguish this fertile period. During the war and in the years immediately following, when materials such as steel, aluminum, bronze, and copper were a military priority, expensive and hard to come by, many sculptors were sustained by drawing.

Drawings offer an inside perspective as revealing as handwriting. They often tell us far more about the creative process than the finished work, for they record the way in which ideas are conceived and developed. In the creation of sculpture, drawing has always been an invaluable tool; it enables sculptors to generate and stockpile ideas without having to worry about their material construction. It is a way to dream on paper.

Sculptors' drawings can be full of conflicting impulses, fits and stops, mistakes and miscalculations absent in the finished sculpture. "The truth of the image is not single," David Smith admitted during a lecture on drawing in 1955, "it is many—the image in memory is many actions and many things—often trying to express its subtle overlapping in only one line or shape." [1]

Drawings by sculptors can also be unpretentious documents, abbreviated notations, or independent works in their own right. Smith and Theodore Roszak, for instance, saw the potential of drawing as a monumental expression; whereas Louise Bourgeois, Dorothy Dehner, Herbert Ferber, Seymour Lipton, and Isamu Noguchi tended to draw on a more intimate scale. Each had their own rapport with drawing and explored its extensions through various techniques and media—ink, pencil, charcoal, conté crayon, gouache, watercolor, and oil paint. The results, ranging from a unitary image or series of related images sketched on a single sheet to a highly finished composition, provide the primary data for a reevaluation of postwar sculptural themes.

World War II had a profound impact on the way sculptors viewed themselves and their work. The war not only shattered many of their former beliefs, particularly in progressive science, technology, and utopian political systems, but caused a crisis of consciousness. Many of the intellectual ideas that formed the basis of a postwar ethos were an

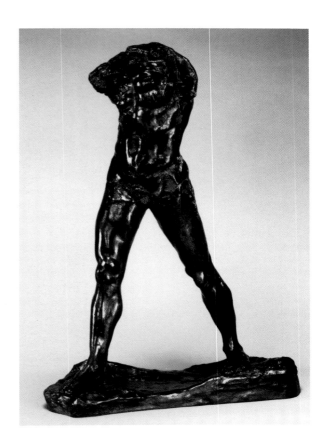

implicit part of the sculptural enterprise. Sculptors, like painters, looked to some of the same sources—anthropology, psychology, sociology—in an attempt to answer some of the same questions concerning the human condition and the nature of the human mind during a time of global crisis. Within the greater context of a postwar intellectual history, sculptors were considered insiders. And yet, when it came to their work, problems arose. Their carved and welded objects appeared too "literal"; they lacked the requisite degree of ambiguity and abstraction that seemed to make painting a more innovative medium. Sculpture's tangibility, its projection in space, was both its difference and its disadvantage at a time when abstraction and representation were often considered to be antithetical pursuits.

Sculptors had their own agenda, even if some of their central themes corresponded with those of painters. Most refused to see abstraction and representation as diametrically opposed, even when such a stance, particularly when it involved figuration, was dismissed by some as academic and retrograde. The figure was to sculptors what the loaded brushstroke was to Abstract Expressionist painters: a fundamental trope, a medium through which basic questions about the self and humankind could be expressed. The figure's viability as a sculptural motif was unquestioned. The 1950s may have been a glorious decade for abstrac-

Auguste Rodin
The Walking Man, 1877
Bronze, 33¼ x 16¾ x 21⅞ in.
National Gallery of Art, Washington,
D.C. Gift of Mrs. John W. Simpson.
(Not in the exhibition)

Alberto Giacometti
Woman with Her Throat Cut, 1932
Bronze (cast 1959), 8 x 34½ x 25 in.
The Museum of Modern Art, New York
(Not in the exhibition)

tion, but it was also a watershed for a new kind of figuration. The challenge was to find ways of using abstraction to reconfigure anatomy in order to make it modern.

In the history of vanguard sculpture, from Auguste Rodin to David Smith and Theodore Roszak, the figure, conceived as a totemic or heroic entity, is an overriding theme.[2] For postwar sculptors, the hero, in particular, had a poignant relevance. The hero's trials were metaphorically played out in the battlefield of the psyche. This psychological dimension made the hero a symbolic role model, an alter ego for men as well as women. Though their interpretation of it varied considerably, all these sculptors saw the heroic act as a risk, an encounter with reality and with one's own irrational impulses, which required a journey beyond what was known and comfortable into foreign, even hostile terrain. The concept of the hero provided a visualization for an individual's confrontation with adversity and self-doubt. For sculptors, the hero signified a personage, a potent metaphor for a vulnerable and yet resilient spirit. Some of the thousand faces of the hero, to borrow from the title of Joseph Campbell's mythological anthology, appear in drawings for Smith's *The Hero* (1951-52), Roszak's *Skylark* (1950-51), Noguchi's *Monument to Heroes* (1943), Lipton's *The Cloak* (1952), Bourgeois' *Femme Maison* (1946-47), and Ferber's *Labors of Hercules* (1948).

History had a profound resonance for postwar sculptors. Many saw their work within a continuum, what the émigré sculptor Jacques Lipchitz described in a 1945 interview with James Johnson Sweeney as "the Great

Stream."[3] Within this "Great Stream," the work of Rodin, Pablo Picasso, Julio González, Alberto Giacometti, Jean Arp, and Henry Moore constitute a kind of sculptural pantheon, a repository of ideas and attitudes that many American sculptors drew from. In the minds of many postwar sculptors, innovation was grounded in tradition—the figurative tradition. And although a number of them—Smith, Ferber, Noguchi, Bourgeois—would later avoid overt figurative and mythical references in their work, at this point such influences were explicit; particularly in their drawings. Some sculptors also saw their formal evolution in terms of art historical schema, which represented another way of historizing what they did. Roszak, for example, described his transition from Constructivism to Expressionism as a transformation from an austere Classicism to a pulsating Baroque. And Noguchi, a Japanese-American, was inspired early on by traditional forms of Japanese art.

Any analysis of postwar American sculptural drawings must take into account the dynamics of space. Not only was space inseparable from an object's initial conception, but philosophically it had vast consequences. Space became the metaphorical matrix for the projection of ideas, and its permutations through drawing set the tenor for a vanguard sensibility. Space was conceived as an active rather than a passive envelope that commingled with the object, an arena in which sculpture and spectator confronted each other. For many sculptors, space signified an expanded field without dimension, a new frontier for the projection of imagination and myth.

Though one would not ordinarily think of the landscape as a sculptural theme, its appearance in drawings was a tangible way for sculptors to reaffirm a connection with nature. What had been, until the 1940s and 1950s, the exclusive domain of painters was now adapted and abstracted as a sculptural motif. David Smith, for example, between 1945 and 1951, developed a series of about twenty sculptural landscapes; in the numerous drawings as well as photographs he made of his work *in situ,* the landscape around his studio at Bolton Landing, New York, was an essential element. Roszak, Ferber, and Dehner frequently conceived of sculptural form in their drawings as issuing from the landscape, and many of Bourgeois' drawings, with their undulating knolls, evoke an imaginary terrain. (Bourgeois' series of "Soft Landscapes," from the late 1960s, can be seen as an extension of this impulse.) Even Noguchi, whose later environmental projects included public playgrounds, bridges, and gardens, during the 1940s conceived of the landscape as a universal trope. The landscape came to have numerous connotations for sculptors: it alluded to or symbolized human anatomy, dream states, destruction and devastation, history, and humankind's essential bond with nature. It functioned both as a universal metaphor and a personal symbol.

Of no less importance than the figure, history, space, and the landscape is drawing's reciprocity with painting. Some sculptors saw no distinction between these two endeavors. Painting for Roszak comple-

mented his sculptural production. Even in the late 1950s, when a traveling retrospective organized by the Walker Art Center assured his reputation as a sculptor, he still thought about painting, even though it was drawing that sustained him in later years. Ferber also embraced painting. Just as Henri Matisse, at various points in his life, took up sculpture as a way of clarifying structural issues and taking a break from painting, Ferber pursued painting for extended periods as a way to relax and investigate new images, some of which relate to his sculpture. His later brazed brass and copper calligraphs, for instance, have a natural affinity to some of his oil on paper drawings, which can be seen as small-scale paintings. The same could be said of Smith's gestural brush drawings begun in the early 1950s. Smith could, and did, equate drawing with painting. As his second wife Jean Freas recalled: "Time and time again he told me he would stop making sculpture when he was sixty. The work was too hard, the dirtiness of it got him down and made his sinuses ache. But painters, he said, lived to be very old, and so would he, always drawing."[4]

That sculptors of this period incorporated aspects of painting into their drawing process is not surprising given that many began their careers as painters.[5] Modernist sculpture evolved out of a dialogue with painting, which may explain, in part, why some of these sculptors sustained a rapport with both media, even after a critic like Clement Greenberg declared their formal "integrity" and "purity" corrupted by such an intermarriage. When it came to vanguard sculpture, Greenberg had definite opinions about what constituted a viable direction. But many sculptors were unwilling to make the transition from an art that was figurative and humanistic to one more formal and non-representational. For them, humanism and formalism were two sides of the same sensibility and there was no reason to change because of popular tastes or critical polemics.

NOTES

1. David Smith, "Drawing," Sophie Newcomb College, Tulane University, March 21, 1955; published in *David Smith*, ed. Garnett McCoy (New York: Praeger Publishers, 1973), p. 137.

2. Rodin's *Walking Man* (1877) can be seen as a sculptural prototype for a dismembered and violated figure. Conceivably a response to the Franco-Prussian War, this sculpture, with its arms seemingly pulled from its sockets and imperfections of casting evident, becomes the modern paradigm for a timeless war effigy.

3. James Johnson Sweeney, "An Interview with Jacques Lipchitz," *Partisan Review*, 1 (Winter 1945), p. 83.

4. Jean Freas, "Living with David Smith," *David Smith: Drawings of the Fifties*, exh. cat. (London: Anthony D'Offay Gallery, 1988), p. 10.

5. The exceptions within this particular group were Ferber, Noguchi, and Lipton, all of whom early on aspired to be sculptors.

3. David Smith, *Untitled*, 1952. CAT. 131

DAVID SMITH

David Smith once described drawing as "the life force of the artist....the most direct, closest to the true self, the most natural liberation of man."[1] Smith drew the way most people speak. It came to him as naturally as breathing, and he did it religiously. He used drawing as an empirical means of tapping the subconscious—a way of bypassing conscious constraints that might otherwise deflect the graphic representation of a flash intuition or dream. Drawing enabled him to generate a steady stream of ideas without having to worry about their actual construction; it was a reprieve from the blazing torch with its spray of dangerous sparks, the promethean struggle with heavy metals that took place in the Terminal Iron Works, that cinder-block edifice he called his studio.

Although the drawings selected for this exhibition are of a relatively large format, Smith drew on all scales, from pocket-sized notepads and 14-by-10-inch coil-ring notebooks to more expansive sheets of the finest fabrico paper. What initially began during the 1930s and 1940s as a process of note taking, a means of recording miscellaneous information and working through possible ideas for sculpture, eventually became in the 1950s a more independent and monumental expression.

As the scale of Smith's drawings expanded, so did his repertory of techniques and materials. Early on he preferred graphite and ink, and in some of the 1940s notebooks brushes were introduced. His sketchbooks were a testing ground for various techniques—images could be gestural, tight and linear, modeled or cross-hatched. He generally preferred brushes—soft sable or stiffer pig-bristle—to pens, and his experimentation with black Chinese ink and egg tempera during the early 1950s was a natural outgrowth of his search for a medium responsive to the nuances of a spontaneously executed line, a dab or swirl, a blob or bleed. In many of Smith's postwar drawings, color became a significant element. By the late 1950s he was using enamel spray paint, a by product of his sculptural process, to create delicate silhouettes which he might then supplement with touches of pencil and ink (Frontispiece).

Smith's drawings and their ultimate sculptural realization are paradigmatic examples of some of the themes that preoccupied American sculptors from the 1930s on. This is particularly true of the figure, a leitmotif in many of the drawings selected for this exhibition. Throughout the 1940s and 1950s, the figure underwent a series of transformations in Smith's work. In the late 1930s and 1940s, its depiction, in works such

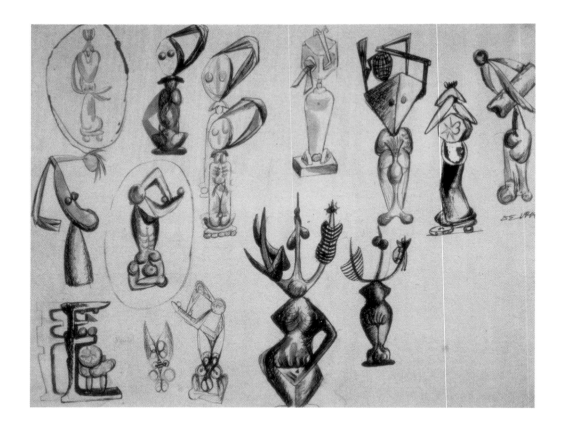

as *Untitled (Study for "Perfidious Albion")* (1944; Fig. 1) and *Personage from Stove City* (1946; Fig. 2), is both a homage to the open and linear assemblages of Picasso and Julio González and an exploration of more biomorphic configurations, many of which are an extension of images first developed in the "Medals for Dishonor" (1937-40). During and after the war, the figure became a cipher for some of Smith's most basic phobias. The "Spectres," a group executed between 1944 and 1946, are hybrid surreal beings, mutated figures or birds, animalistic incarnations of contemporary war planes. These bizarre creatures had a collective dimension: they symbolized the greed, corruption, and materialism that caused wars and killed people. And their association with the winged cannon-phallus, which appears as the central protagonist in a series of "rape" scenes Smith modeled and drew, not only signifies the horrors of war and military imperialism, but suggests Smith's own sexual frustration and ambivalence toward women. It is hard to separate the sociopolitical implications of such imagery from its psychosexual innuendos; it would appear to function on both levels.

Smith's concept of drawing gravitated between representation and abstraction. An untitled drawing from 1955 (CAT. 134), consisting of horizontal bands of black ink brushed in from top to bottom, is one of the most non-objective images he ever made. Despite its affinity to landscape, this series actually evolved out of figural drawings whose initial

1. David Smith
 *Untitled (Studies for
 "Perfidious Albion")*, 1944
 CAT. 124

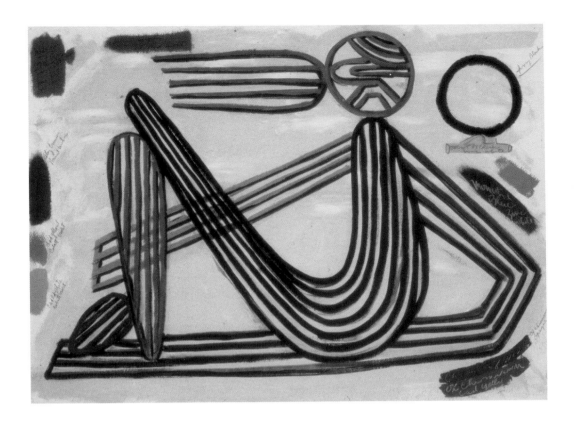

2. David Smith
*Study for "Personage
from Stove City,"* 1946
CAT. 125

orientation was vertical rather than horizontal. Other postwar drawings
(Figs. 3, 4) depict the figure as a mutated personage with gnarly limbs and
an enlarged head, or as an entity that seems to explode across the sheet.

For Smith, drawing was an act of self-identification, and abstraction,
in some cases, a way of masking certain feelings within an image that
might otherwise appear too obvious.[2] Beginning in the 1950s, he began
to explore a more abstracted figuration through an extended series of
totemic drawings (Figs. 5, 6), which set the pace for a series of
"Tanktotems." One of the most significant of Smith's totemic figures is
The Hero (Fig. 7; 1951-52), for which only two preliminary drawings exist
(Fig. 8).[3] *The Hero* marks a transition from the volumetric and biomorphic
work of the 1940s to the leaner, more reductive "Tanktotem" and
"Agricola" series, and its multivalent character belies the apparent
simplicity of its formal structure: a single vertical shaft connected to a
lozenge-shaped base supports a double-sided elliptical eye/head and a
rectangular element that enframes two small triangular shapes.

In both studies the piece is rendered in profile and frontal views, and
the rectangular torso appears as a volumetric entity within which various
glyphs can be perceived. The disposition of glyphic signs within an
imaginary space frame recalls an untitled drawing executed two months
earlier than the *Hero* drawing,[4] as well as *The Letter*, a sculpture
completed in 1950. Initially conceived as a rectangular plinth, *The Hero's*

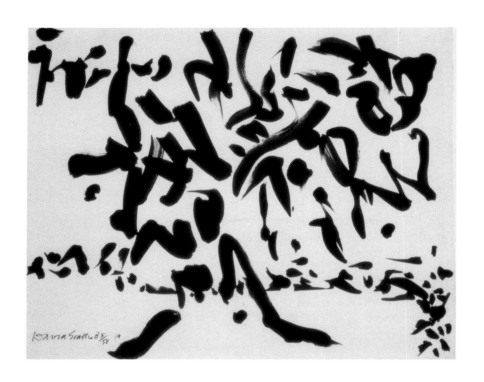

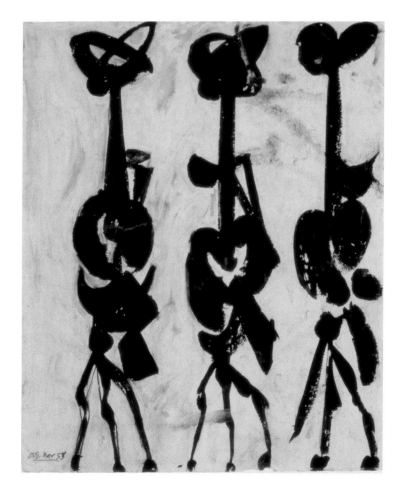

4. David Smith
Untitled, 1958
CAT. 136

5. David Smith
Study for "Tanktotems," 1953
CAT. 133

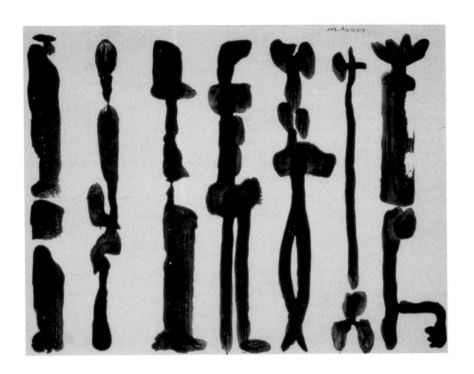

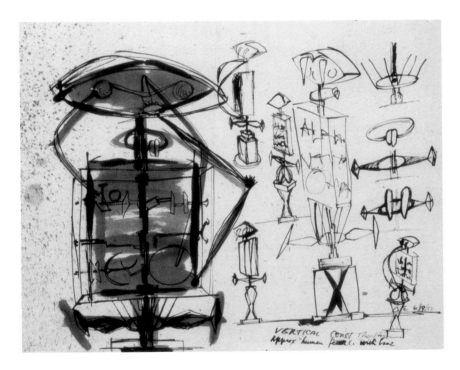

6. David Smith
Untitled, 1953
CAT. 132

8. David Smith
The Study for The Hero, 1951
CAT. 129

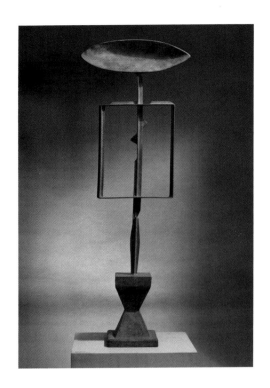

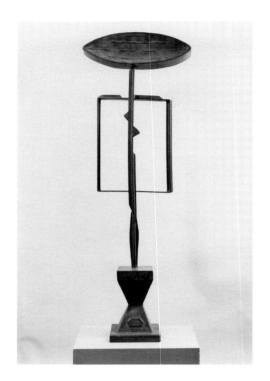

7. David Smith, *The Hero*, 1951–52
Steel, 73 ¹¹/₁₆ x 25 ½ x 11 ¾ in.
The Brooklyn Museum.
Dick S. Ramsay Fund
(Not in the exhibition)

9. David Smith, *The Hero*
(backside)

base developed into two pyramidal shapes connected tip to tip. What is curious about these studies is the proliferation of details—armlike extensions that connect the eye/head with the torso and another set below the torso that projects to either side; two bladelike leaves that droop off the eye/head; and two bulbous forms supporting the lower arms that rest on the base—all of which were eliminated in the final version. An inscription—"VERTICAL const/The Hero Approx human female with base"—appears on one drawing, but nowhere is any gender suggested.

Smith's concept of the hero functioned on many levels. On the one hand, it was a way for him to acknowledge important influences, and it is no coincidence that in his initial sketches, *The Hero's* base resembles a section of Brancusi's *Endless Column;* its rectangular torso, meanwhile, can be seen as a homage to painting. Smith held Brancusi in the highest esteem, along with painters such as Picasso, Kandinsky, and Mondrian.[5] This kind of hero worship affirmed historic precedents that forged his aesthetic. On the other hand, the notion of the heroic as a metaphor for an encounter with one's subjectivity is implied through the enlarged eye/head that dominates the upper portion of the piece. The symbolic implications of the eye/head—the dichotomy between internal and external vision, seeing and dreaming—have been noted by other writers.[6] It should added, however, that Smith's fascination with the head began as early as 1933 and continued throughout the 1940s and 1950s.[7] And its representation as an object sometimes placed, like a still life, on a table, not only signified a symbolic sacrifice, but was a means of elevating and

isolating this part of the body as the origin of consciousness and creativity, irrational and potentially harmful impulses. The head's prominence in drawings for *The Hero* suggests that Smith wanted to emphasize both its personal and universal significance.

The Hero has been described as both a self-portrait and a female totem. Although there is no indication of gender in the preliminary drawings, in the final version, the two triangular shapes welded to its stem determine its identity as female. Smith referred to many of his figurative works as "girls," but such an attribute, given this particular context, raises questions. Why, for instance, would he endow the hero, generally conceived as a masculine entity, with breasts? And why would he heroize the feminine within a totemic representation?

In primitive societies the totem was a venerated or sacred object, such as an animal or botanical element, which had powerful implications within a particular tribe. Frequently, identification with a totem was accompanied by prescribed laws or taboos that protected the totem and made it inviolate. The laws of totemism, which helped to regulate incestuous behavior within tribes, centered on what one could or could not possess.[8] Smith's attitude toward the feminine was complicated. What the terms of totem and taboo offered him, above and beyond their Freudian associations, was a conceptual framework through which his ambivalence toward the feminine could be projected.

During his presentation at the "New Sculpture Symposium," Smith made the following statement: "A Chinese painter explained that although the long blade leaves of an orchid droop toward the earth, they all long to point to the sky. This Chinese attitude of cloud-longing is an eye through which I view form in works of celebration and, conversely, in those of a specter nature." [9] Delivered shortly after *The Hero* was completed, this statement may have a direct bearing on the meaning of the piece. A curious and generally overlooked aspect of the eye/head is a series of brazed formations that appear on what Smith considered its backside (Fig. 9). Could these markings, which replace the bladelike forms in the preliminary drawing and resemble abstract clouds, refer to this attitude of cloud-longing and thereby symbolize the spectral nature of the hero's plight? The spectre was a metaphor for the darker side of Smith's personality and something he struggled with throughout his life. His association of the spectre with a female totem is one of the most original, and yet poignant, interpretations of the heroic theme.

In a photograph Smith took of *The Hero in situ*, the landscape of Bolton Landing appears in the background. Smith frequently photographed his sculpture in the landscape, which also became the subject of many drawings. In an untitled ink and tempera drawing from 1951 (PL. I), he transformed the landscape into a primordial setting, whose lower strata seethe with chaotic life and whose upper region carries three totems, recalling an earlier piece titled *Sacrifice* (1950). In a later untitled work from 1959 (Fig. 10), the mountains around Bolton Landing are

abstracted into an overall composition of traversing lines and dense, agitated masses. The landscape offered Smith a refuge, a quiet place to pursue his work, which found a natural site among the mountains, the lake, and the sky. It not only signified an edenic retreat but a return to primal roots. Smith made verbal free associations when contemplating the landscape; his words conjure up images of primeval struggle, vanquished civilizations, and atavistic nightmares. Around 1947, Smith wrote a poem entitled "The Landscape":

> I have never looked at a landscape without seeing other landscapes
> I have never seen a landscape without visions of things I desire
> and despise
> lower landscapes have crusts of heat—raw epidermis and the choke
> of vines
> the separate lines of salt errors—monadnocks of fungus
> the balance of stone—with gestures to grow
> the lost posts of manmaid boundaries—in molten shade a petrified
> paperhanger who shot the duck
> a landscape is a still life of Chaldean history
> it has faces I do not know
> its mountains are always sobbing females
> it is bags of melons and prickle pears
> its woods are sawed to boards
> its black hills bristle with maiden fern
> its stones are assyrian fragments
> it flows the bogside beauty of the river Liffey
> it is colored by Indiana gas green
> it is steeped in veritable indian yellow
> it is the place I've traveled to and never found
> it is somehow veiled to vision by pious bastards and the lord of Varu
> the nobleman from Gascogne
> in the distance it seems threatened by the destruction of gold.[10]

The landscape had multifarious associations for Smith, who saw it as a reprieve from the frenetic pace of the urban metropolis and a foil against which he projected his imagination. During the postwar period, the landscape, like the figure, became a vehicle for innumerable images that reflect the complex machinations of a creative mind.

Notes

1. David Smith, "Drawing," Sophie Newcomb College, Tulane University, March 21, 1955; published in *David Smith*, ed. Garnett McCoy (New York: Praeger Publishers, 1973), pp. 120, 137.

2. It was Dorothy Dehner who suggested that "abstraction appealed to Smith as a way of making use of his deepest feelings without revealing himself completely"; see Karen Wilkin, "The Drawings of David Smith," *The New Criterion*, 8 (March 1990), p. 16.

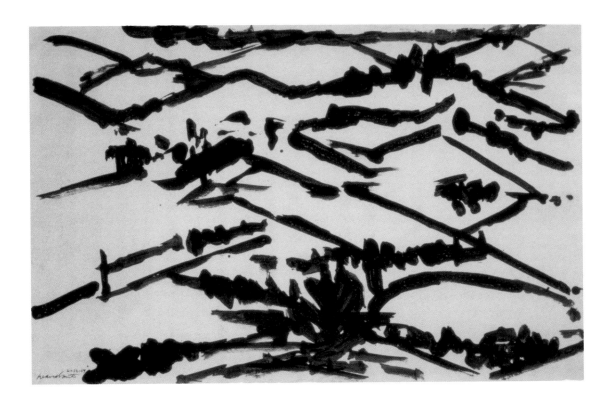

3. Besides the drawing illustrated here, another series of sketches appear in a 7-by-5-inch notebook; Archives of American Art, Smithsonian Institution, Washington, D.C., NDSmith4/167.

4. This drawing, dated 4-8-51, is reproduced in *David Smith: Drawings of the Fifties*, exh. cat. (London: Anthony d'Offay Gallery, 1988), no. 6.

5. "Since the turn of the century," Smith said during the "The New Sculpture Symposium" at The Museum of Modern Art in 1952, "painters have led the aesthetic front both in number and in concept"; published in McCoy 1973, p. 82.

6. See Rosalind E. Krauss, *Terminal Iron Works: The Sculpture of David Smith* (Cambridge, Massachusetts: M.I.T. Press, 1971), p. 91; and Ann Eden Gibson, "Theory Undeclared: Avant-Garde Magazines as a Guide to Abstract Expressionist Images and Ideas," Ph.D. dissertation, University of Delaware, 1984, pp. 206-11.

7. Some of the earliest representations of the head include *Agricola Head, Chain Head, Head with Cogs for Eyes*, and *Saw Head;* see Rosalind E. Krauss, *The Sculpture of David Smith: A Catalogue Raisonné* (New York: Garland Publishing, 1977), figs. 17a-b, 18, 19, 21.

8. Rosalind Krauss, the first writer to identify *The Hero* as both a self-portrait and female totem, believed that Smith's concept of totemism developed around a formal strategy, whereby "the form of his work and the notion of the totem became two interlocking and reciprocal metaphors which point to the same thing: a statement of how the work could not be [visually] possessed"; see Rosalind E. Krauss, *Passages in Modern Sculpture* (Cambridge, Massachusetts: M.I.T. Press, 1977), p. 154.

9. David Smith, "The New Sculpture"; published in McCoy 1973, p. 83.

10. Quoted in McCoy 1973, pp. 198, 199.

10. David Smith
Untitled, 1959
CAT. 137

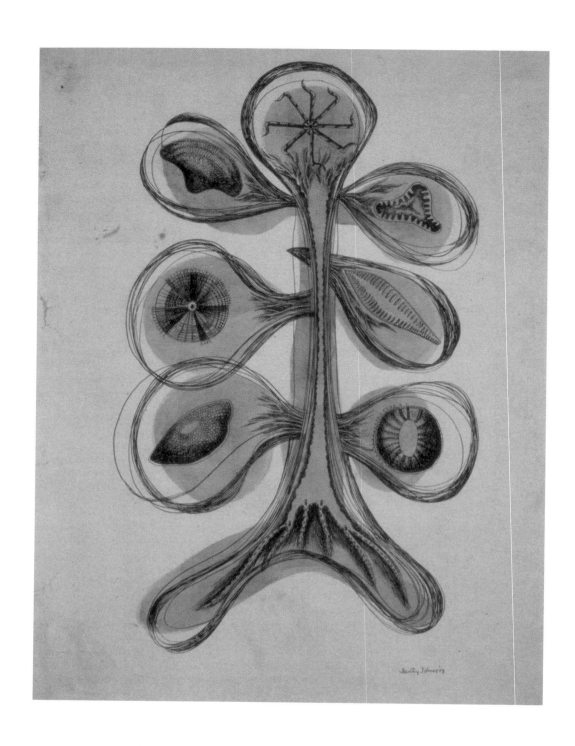

12. Dorothy Dehner, *The Gift Tree*, 1948. CAT. 23

DOROTHY DEHNER

During an interview with Karl Fortess, Dorothy Dehner mentioned that she had been drawing at the age of three.[1] One gets the impression that she enjoyed drawing and that it came easy to her. Throughout the 1930s, 1940s, and 1950s drawing was her primary means of expression. The extent to which it enabled her to continue functioning as an artist up until the early 1950s has a lot to do with her first husband, David Smith.

Dehner's early career is inseparable from Smith's through a marriage that lasted twenty-five years. In the late 1920s, both artists enrolled at the Art Students League, took classes from Jan Matulka and Kimon Nicolaides, and studied painting before they became sculptors. Under different circumstances, Dehner probably would have pursued sculpture far sooner than she did, in the mid-1950s, after her divorce from Smith. One could say that Smith drove Dehner to draw. But such a statement simplifies a far more complex relationship. There is no doubt that during the time they were married Dehner's own career was secondary. She later admitted that living with someone as prolific as Smith made creating her own art difficult. "I had all kinds of inner problems about working at all...," she told Garnett McCoy.[2] Dehner's marriage to Smith may have compromised her own productivity, but it also resulted in a fruitful exchange of ideas. The story of artists who marry other artists is both a fascinating and, depending on the individuals involved, a disheartening phenomenon. To see Dehner's relationship with Smith in the context of other artistic couples—Robert and Sonia Delaunay, Jean and Sophie Taeuber-Arp, Willem and Elaine de Kooning, Jackson Pollock and Lee Krasner—is to realize the fine line between collaboration and competition, sharing and withholding ideas. Dehner's story, however, has its own particular dynamics, which help to elucidate her drawings.

Dehner's drawings from the 1940s and 1950s are remarkable for their delicate control. And yet many display an expressionistic abandon, as well as a tentative quality that sometimes bleeds through (PL. II). She preferred paper sheets of moderate dimensions, generally not exceeding 25-by-19 inches, and gravitated toward pen and ink, which she frequently overlaid with subtle washes. In many works, the paper functions as an expansive white ground for geometric patterns and biomorphic forms. Fluctuating between abstraction and representation, her imagery can be sparse and minimal, dense and compacted.

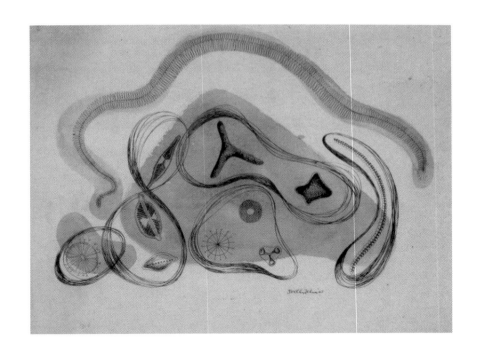

A series of ink and watercolor works from the late 1940s can be seen as confessional images reflecting an ambivalent state of mind. While drawings such as *Landscape for Cynics* (1945), *Country Living (Bird of Peace)* (1946), and *Desert* (1948; not in the exhibition) embody anguished feelings of alienation symbolically played out in barren landscapes, another series from the same period is more optimistic.[3] With their proliferation of oceanic forms—star fish, sea urchins, shells, and coral—*Measure of Time, Leewenhoek's Dream #3* (Fig. 11), and *The Gift Tree* (Fig. 12) (all 1948) are recollections of a happier, more carefree time, when she and Smith spent nine months in the Virgin Islands in 1931. These "Virgin Island" images also deal with Dehner's identity as a woman. Vaginal-like forms appear in *Measure of Time* and *The Gift Tree*, and another drawing, titled *Virgin Island Series* (1948; not in the exhibition), depicts small figurines recalling the paleolithic Venus of Willendorf. It was as though Dehner, while trying to salvage her past with Smith, was also searching for her own. These biomorphic constellations, a far cry from the romanticized and documentarian "My Life on the Farm" series of 1942, can be seen as a form of personal archaeology—the projection of one's own identity within a greater collective history.

Another gouache drawing from this period, *Personage* (about 1948; Fig. 13), symbolically suggests alienation in a male and female couple. Some of the same microcellular forms appear as secondary motifs floating between the figures. What is curious about this image, besides each figure's skeletal-like rendering, is the concentric lines that surround each one. Dehner often encircled various forms within a composition as a way of delineating and emphasizing their presence. Her use of multiple

11. Dorothy Dehner
Leewenhoek's Dream #3, 1948
CAT. 24

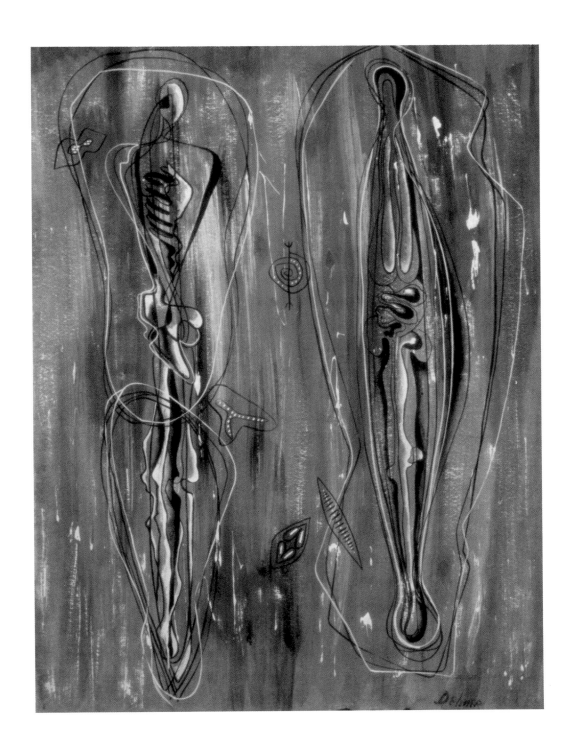

13. Dorothy Dehner, *Personage (Male/Female),* 1948. CAT. 26

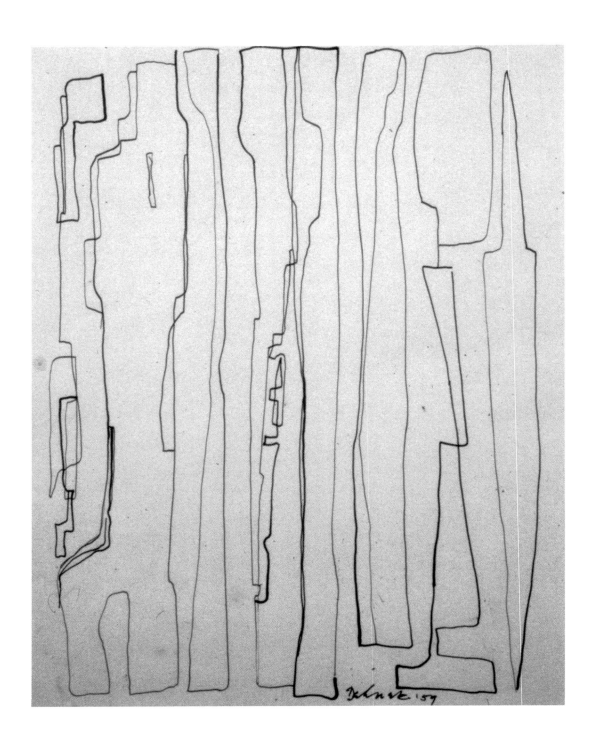

14. Dorothy Dehner, *Untitled*, 1959. CAT. 40

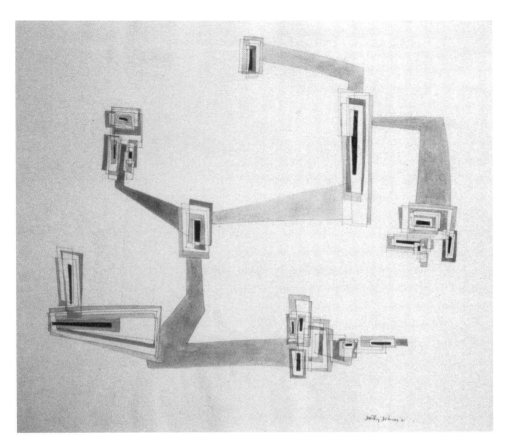

outlines here, in what is essentially a confrontation between genders, creates a poignant sense of estrangement. Represented together and yet isolated from each other, both figures seem to exist in a world of their own.

When Dehner finally began to make sculpture, her initial forays were through drawing. She took classes in sculptural techniques at the Sculpture Center, and by 1955 was casting work in the traditional lost-wax method. In some cases she bypassed preliminary sketches through empirical modeling in wax. But she continued to draw, and in both her drawings and sculpture a strong figurative emphasis persists. A number of pieces cast in bronze—*Signpost* (1956), *Jacob's Ladder #1* (1957), *Queen* and *Untitled (Hanging Sculpture)*, the latter two of 1960—are totemic in their vertical orientation, organic in the way they develop part to part. In two untitled ink drawings from 1959 (CATS. 40, 41; Fig. 14), the figure is conceived as a composite entity composed of miscellaneous forms stacked on top of each other or connected side to side. Dehner's conception of the figure could be heroic, massive, and volumetric. But she also rendered the figure as an insubstantial spirit. *Wraiths from a Small Village*, (CAT. 38) an ink and watercolor drawing from 1956, recalls the innumerable brush and ink drawings Smith generated during this period. There is a similar kind of presentation, a friezelike procession of totemic figures across the sheet, and internal articulation. But compared to Smith's, Dehner's figures are wispy; they seem to hover over the sheet

15. Dorothy Dehner
The Way #10, 1951
CAT. 34

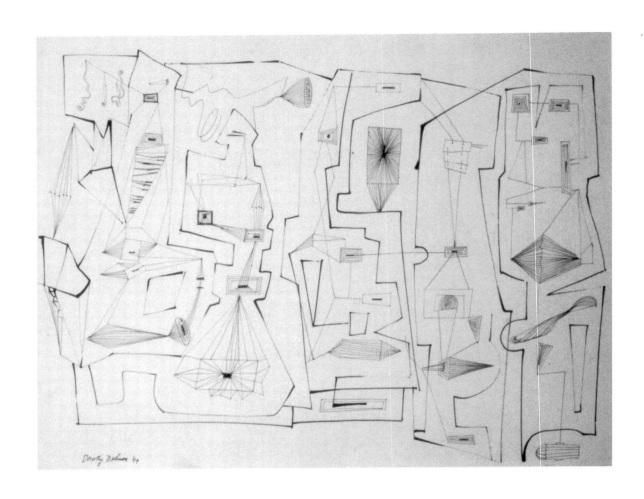

16. Dorothy Dehner, *Untitled*, 1949. CAT. 28

like weightless souls. This ethereal quality, a lightness of touch that distinguishes aspects of both her representational and abstract images, is a hallmark of Dehner's graphic style.

Whereas some of Dehner's drawings—a lone figure pacing aimlessly amidst a desolate landscape or the skeleton of a prehistoric bird hovering above a craggy mountain range—are more obvious self-projections by an individual grappling with difficult circumstances, others can be seen as equivalents for a troubled psyche trying to stabilize itself. The act of searching is an apt metaphor for many of Dehner's more abstract and geometric works, some of which are labyrinthine. In *The Way* (1951; Fig. 15), as well as two untitled works from 1949 (CATS. 28, 30; Fig. 16), Dehner's line, as it traverses the sheet, creating patterns of enclosed and open forms, sometimes resolves in a series of concentric shapes—lozenges, circles, squares. Like floating islands surrounded by expansive space, these formations are often interconnected through a network of delicate lines or channels of wash. In some, the resulting image seems schematic and flat; in others, a recessive perspective suggests a vortex extending toward infinity. In a review of Dehner's first one-person exhibition of watercolors at the Rose Fried Gallery, critic Dore Ashton may have been referring to images such as these when she wrote that Dehner's work "reveals a delicate sensibility and temperament which might correspond to the aesthetic personality of Paul Klee."[4] Like Klee, Dehner's line could be tense and relaxed, wiry and idiosyncratic. Her linear fields are like psychic maps. While certain images evoke a landscape, others suggest that formal abstraction was a means of creating another, more predictable world.

NOTES

1. Karl Fortess, "Interview with Dorothy Dehner," February 15, 1973, audiotape, Archives of American Art, Smithsonian Institution, Washington, D.C. Dorothy Dehner Papers.

2. Garnett McCoy, "Interview with Dorothy Dehner," n.d., Archives of American Art, transcript, p. 17.

3. Joan Marter has discussed these drawings both in the context of contemporary political circumstances and of disturbing episodes in Dehner's personal life at Bolton Landing; see Joan M. Marter, *Dorothy Dehner: Sixty Years of Art*, exh. cat. (New York: Katonah Museum of Art, 1993), pp. 8–9.

4. Dore Ashton, "Dorothy Dehner," *Art Digest*, 26 (May 15, 1952), p. 19.

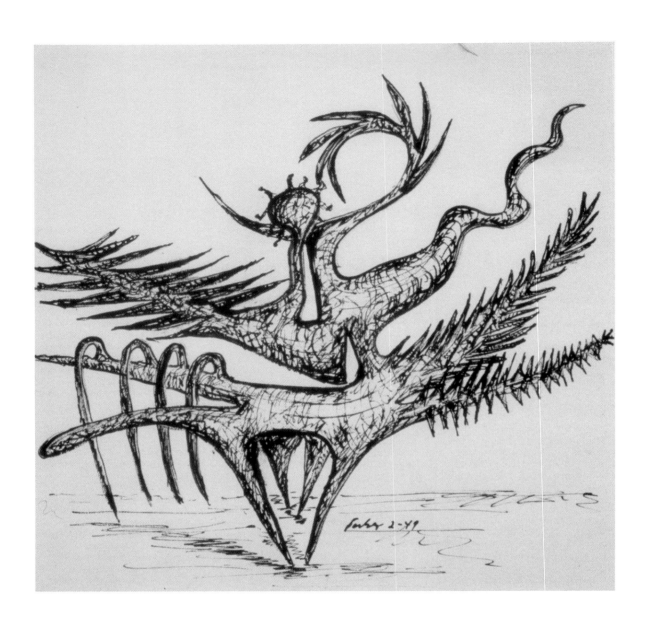

18. Herbert Ferber, *Untitled*, 1949. CAT. 52

HERBERT FERBER

It is curious how certain individuals came to be sculptors. Herbert Ferber and Seymour Lipton both discovered their aptitude for sculpture while studying to be dentists. Molding molars and crowns may seem far removed from welding sculpture, but in Ferber's case dentistry not only sustained him during lean times, when it was difficult to sell sculpture, but early on gave him his first opportunity to draw. He later told Irving Sandler, "While at dental school [in 1926-30] I had to make anatomical drawings, and discovered that I had some talent for making that kind of naturalistic drawing."[1] What began as a requisite part of his medical training became an essential aspect of his sculptural process. Ferber drew to explore in two dimensions what might eventually be realized in three, and during the 1940s and 1950s drawing set the pace for most of his ideas. Many, executed in subtle overlays of ink, wash, and gouache, revolve around the figure and its biomorphic transformation. Others, oil paint on paper, investigate more non-representational imagery, such as calligraphs, which became the basis for sculpture conceived within pictorial frames and cages, enclosed environments, or outdoor architectural settings.

Ferber's initial forays into drawings for the most part were based on traditional conceptions of the monolithic figure. Stylistically, these early works, executed during the Depression, reflect William Zorach's robust classicism and Gaston Lachaise's exaggerated anatomies, as well as a sociopolitical orientation.[2] What eventually transpired was a radical re-evaluation of the figure inspired primarily by Henry Moore's innovative work.[3] Moore violated the monolith by displacing, or eliminating, mass and volume and allowing space to flow through and around the object. His "open-form" sculpture, coupled with his own variations through drawing, encouraged Ferber to take a similar approach. "I spent a whole year," Ferber later recalled, "I think it was from 1946 to 1947, doing no sculpture at all but just doing drawings, working my way out of the Henry Moore influence. It was such a strong influence that I realized that if I were to make any sculpture it would look too much his work. I simply made drawings so that I could use them as a kind of catharsis, cathartic in order to get rid of the Moore influence."[4] Ferber's burst of drawing actually began somewhat earlier, about 1944-45. The impetus may have been cathartic, but it was also pragmatic given the scarcity of sculptural materials during and after the war.

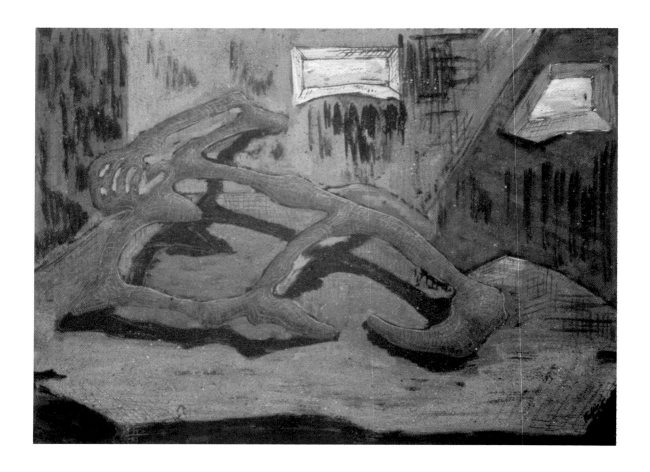

Ferber saw Moore's influence as something he had to assimilate and, ultimately, purge through drawing. But this relationship deserves a closer examination. During the 1930s, Moore, together with art historian Herbert Read, formulated a theory of Vitalism.[5] An elusive concept colored by the earlier writings of Henri Bergson (particularly his notion of life force, or *élan vital*), D'Arcy Thompson's *On Growth and Form* (1917), and Henri Focillon's *La vie des formes* (1934), Vitalism came to embody a poetic and philosophical stance that elevated artistic intuition above scientific rationalism and sought to imbue life into inanimate material. Its quasi-religious overtones, traceable to Rodin, Brancusi, and Arp, were probably not something Ferber endorsed, but its universal reverence for nature, and the way in which abstract form could function as an equivalent for psychic states and dramatic encounters, was certainly germane to his postwar sensibility.

In many of Ferber's drawings from the middle to late 1940s, the figure is reconstituted as deformed and full of voids. In *Study for "Head in Hand"* (1945; Fig. 17), a reclining skeletal effigy is depicted within an enclosed chamber relieved by two small windows. In many representational and abstract drawings, Ferber dealt with antithetical principles of containment and extension, form confined in constricted spaces or

17. Herbert Ferber
Untitled (Study for "Head in Hand"), 1945
CAT. 43

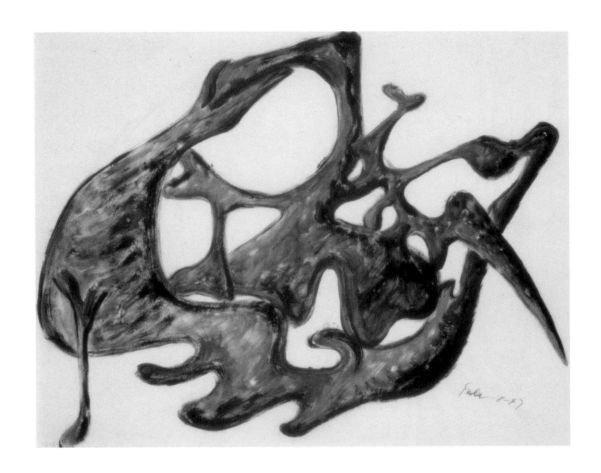

exploding in all directions. For Ferber, space was a tangible entity that impacted on the object, as well as a subconscious realm without dimensions. Space made sculpture responsive to temporal circumstances and at the same time offered a metaphorical arena into which a sculptor could project his imagination. In a statement for *The Tiger's Eye*, Ferber wrote, "The sculptor is too often seduced by form; space is the unlimit of his medium. *Surrational space* [Ferber's italics], charged with form, sprung, tense as a steel coil, from those layers of being not subject to the censorship of verisimilitude. Space and form take shape concomitantly in creating an arena where the creative personality of the artist is in anxious conjunction with his perception of the world about him." [6] Ferber's notion of traditional monolithic sculpture as "centripetal" and its postwar transformations as "centrifugal" revolved around the idea of a displaced center. What had previously been elevated as a unitary and inviolate mass was now debased, dismantled, and prey to forces that threatened its existence. The void signified an exposed condition. The lack of a center was equivalent to the absence of a soul.

In Ferber's drawings from the late 1940s, the figure is both a vulnerable being and an aggressive creature, spiky, barbed, and ready to defend itself (Fig. 18). Many untitled images, biomorphic forms inter-

19. Herbert Ferber
Untitled, 1947
CAT. 45

37

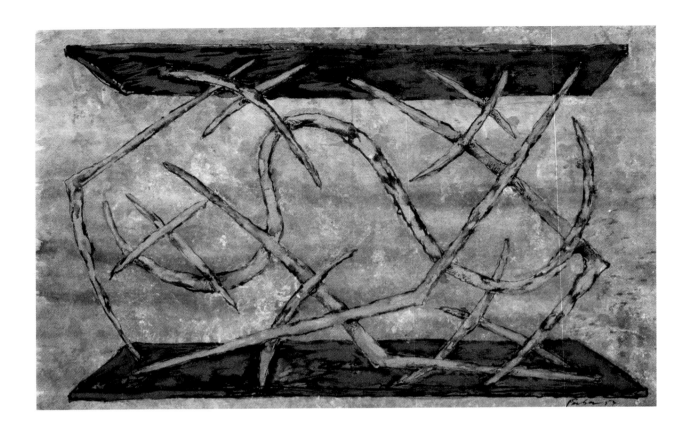

twined in precarious configurations (Figs. 19; PL. III), are analogues for struggle and confrontation. Tightly wound and obsessively drawn, these images are animated by nervous energy.

By the early 1950s Ferber had begun to move beyond the anthropomorphic character of his earlier work. Although figurative references continue to appear, these seem secondary to an investigation of non-representational imagery. With the rise of Abstract Expressionism, the figure's humanistic implications and European associations were considered retardataire by those favoring more formalist criteria. If representation was seen by some to be incompatible with abstraction, the figure became an obvious point of contention. Some sculptors, like Smith and Roszak, continued to evoke the figure but used abstraction to obfuscate its representation. Though one notices a similar tendency in some of Ferber's drawings, he seemed more sensitive to polemics surrounding the figure. This may explain, in part, why he gravitated toward a sculptural abstraction that emulated painting.

In a series of untitled ink, gouache, and wash drawings (CATS. 57, 58; Fig. 20), Ferber developed a sculptural equivalent for an Abstract Expressionist brushstroke. He called these "calligraphs," and they became the basic element within an extended series of works conceived in cages and frames. In his "roofed sculpture," for example, he simulated a partial enclosure delineated by two horizontal planes, which became an

20. Herbert Ferber
Untitled, (Study for
"Roofed Sculpture"), 1954
CAT. 58

38

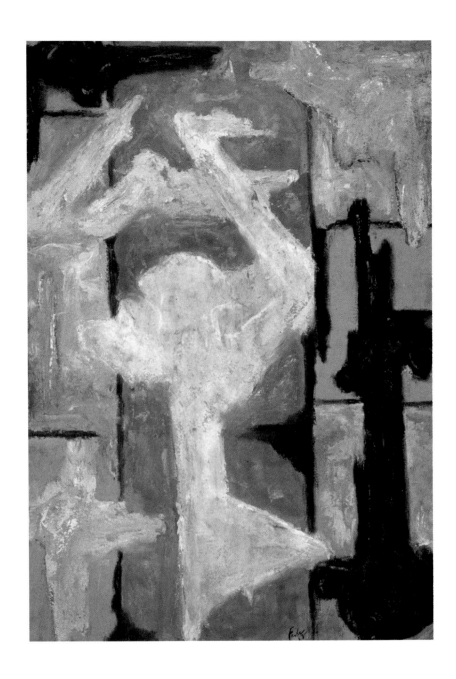

arena for the interaction of various curves, angles, and straight lines. Suspended in space, these explosive configurations, which contain some of the same biomorphic forms that appeared in earlier drawings, defy gravity. Ferber's "roofed sculpture" was a way of projecting abstract form into a specific context and further exploring its gestural implications.

The affinity of the calligraphs to painting is not surprising given Ferber's own inclinations and sympathetic associations. Adamant about sculpture's reciprocity with painting, he set out to bridge the perceptual gap between what many considered to be divergent disciplines. In this respect, he was assisted by the painter/critic Barnett Newman, who wrote

21. Herbert Ferber
Untitled, 1958
CAT. 61

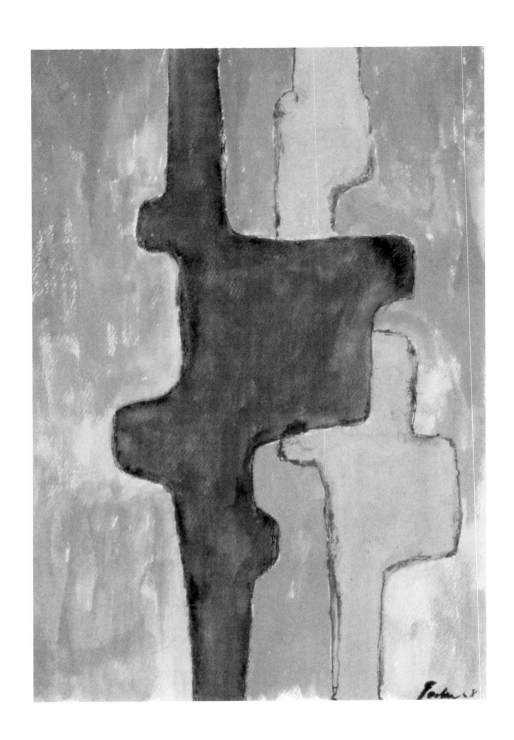

22. Herbert Ferber, *Untitled*, 1958. CAT. 63

the foreword to his one-person exhibition at the Betty Parsons Gallery in 1947-48. The crux of Newman's text, which described Ferber's surreal hybrids as a reworking of the "heroic style" through "heroic gesture," was an attempt to bring Ferber's work into a discourse with painting.[7] If gesture signified a painterly expression, Newman's heroic terminology made the association clear.

There is no doubt that painting assumed an important place in Ferber's sculptural development. There were periods, for instance, between 1958 and 1962, when he painted almost exclusively, and a series of oil on paper pieces from 1958 (CATS. 59–62; Fig. 21) represents the initial phase of this exchange. Although they are not gestural as some of the calligraphs are, they do have the empirical quality of an oil sketch. They also have an affinity to Mark Rothko's earlier "multiform" pictures and Clyfford Still's primordial landscapes, in the way that paint is laid on the paper, in the partitioning of the ground, and in the combination of amorphic and geometric forms. As analogues for transitional states, these painted works are an extension of earlier biomorphic drawings.

Ferber's use of gesture to generate non-representational configurations was a way of playing up the formal integrity of his work while playing down its anthropomorphic innuendos. And yet some of his later works still have a strong figurative inflection through their upright orientation or, in the case of certain calligraphs, in their assumption of a stance. A more overt figuration is evident in an ink, gouache, and oil drawing from 1958 (Fig. 22). These two vertical forms, one rendered in red, the other in yellow, became the basis for a series of life-size personages executed in brazed brass. Harking back to *He Is Not a Man* (1950), these reductive beings suggest the figure's persistence in Ferber's postwar work.

NOTES

1. Irving Sandler, "Interview with Herbert Ferber," April 22, 1968, transcript, Archives of American Art, Smithsonian Institution, Washington, D.C., p. 1. Herbert Ferber Papers.

2. For more detailed biographical information, see the monographs by Wayne V. Anderson, E.C. Goossen, and William C. Agee, listed in the bibliography.

3. Moore's work would have been readily accessible to Ferber through numerous New York exhibitions and publications; see William C. Agee, *Herbert Ferber, Sculpture, Painting, Drawing: 1945-1980*, exh. cat. (Houston: Museum of Fine Arts, 1983), pp. 11-12.

4. Sandler, "Interview with Herbert Ferber," p. 10.

5. For a discussion of Vitalism, see Herbert Read, "The Vital Image," *A Concise History of Modern Sculpture* (New York: Praeger Publishers, 1964), pp. 163-228.

6. Herbert Ferber, "Statement," *The Tiger's Eye*, 2 (December 1947), p. 44.

7. Barnett Newman, "Herbert Ferber," *Barnett Newman: Selected Writings and Interviews*, ed. John P. O'Neill (Berkeley: University of California Press, 1990), pp. 110-11.

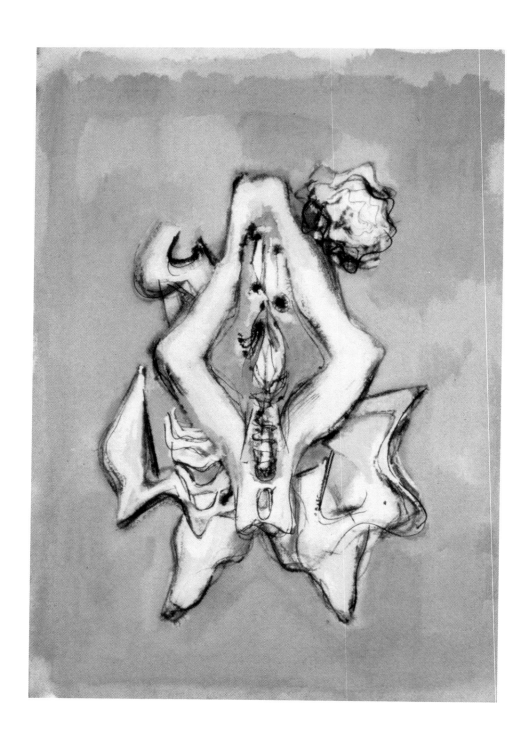

23. Theodore Roszak, *Study for Sculpture (Sea Quarry)*, about 1945. CAT. 109

Theodore Roszak

World War II completely altered Theodore Roszak's worldview and the direction of his art. Death, destruction, and the devastation of two Japanese cities revealed the darker side of technological progress. What previously had been a positivistic embrace of utopian systems was seriously in question by the end of the war. Roszak's shattered faith in science and technology was replaced by a renewed faith in nature, in change and transformation, and in atavistic motifs that reaffirmed basic values. He wanted his work to ask questions (rather than posit definitive answers), to provoke, disturb, even rankle. He also wanted it to evoke archetypal themes and embody a life force that was destructive as well as constructive. In Roszak's rejection of Constructivism and conversion to Expressionism, drawing played a catalytic role.

Roszak's sculptural conception was inseparable from drawing. "Instead of working the medium for ideas," he said during the "The New Sculpture Symposium," "I prefer to have an idea before working." [1] A piece might undergo dramatic changes during its construction, but the basic character of its image, derived from a drawing, usually remained intact. The insistent linearity of Roszak's postwar work, coupled with his method of constructing welded-steel armatures covered, or partially covered, with sheets of brazed steel, was a direct extension of drawing. A facile draftsman who preferred various pens and nibs, he first drew the basic outline of an image, then further articulated the interior with a variety of strokes, dots, dashes, cross-hatching, and brushed-in washes. Any given image often contains secondary and tertiary imagery, a fascinating aspect of Roszak's drawings, whose scale varies from modest notebook sketches to monumental sheets extending more than 6 feet across.

Drawing was the backbone of Roszak's life work, and he recalled doing it by the time he was five or six. "Drawing was one of my earliest responses," he told Harlan Phillips, "it was automatic. It was simple to do. It was available. There was always paper and something to scratch with, and I began drawing very, very early in life." [2] For Roszak, the product of a lower-middle-class Polish family that immigrated to Chicago in 1907, drawing provided a creative outlet for many adolescent frustrations. At that time he must have realized its expressive potential, and during the war years it functioned in a similar capacity. Between 1943 and 1946, when a scarcity of material made it virtually impossible to create sculpture, he channeled his creative energy into an extended

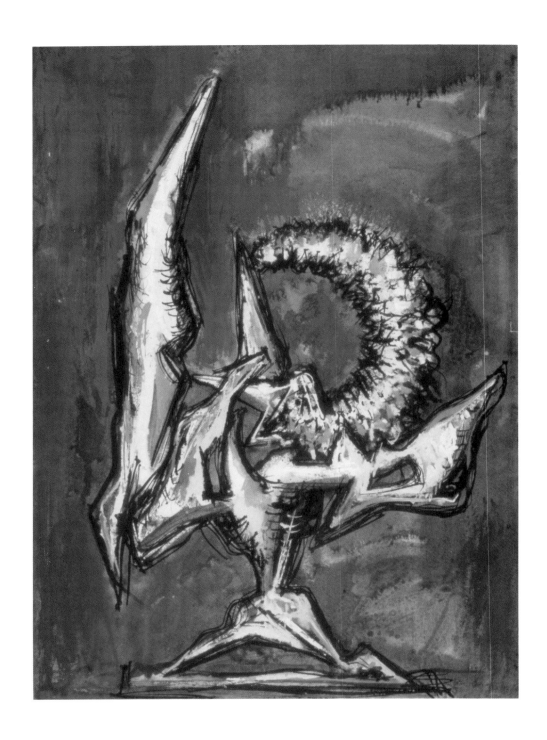

24. Theodore Roszak, *Study for "Thorn Blossom,"* about 1947. CAT. 112

series of about sixty-five gouaches. Most of these works were never exhibited during the artist's life time; like other aspects of his work, including the photograms, certain drawings and paintings, they remained in his studio.[3]

The gouaches (CATS. 108, 109, 112), which mark Roszak's transition from Constructivism to welded-steel sculpture, are distinguished by their combination of drawing and painting. Just as painting combined with plaster relief had been a transition toward freestanding constructions during the 1930s, now, combined with drawing, it functioned similarly as a means of generating expressionistic images whose extensions were also sculptural. Roszak had used gouache in some of his earlier drawings and pochoirs. That he took it up again, at this juncture, was both an act of necessity and emulation. Unlike steel and other industrial materials, gouache and paper were easy to obtain. Also, drawing was something he could do in his spare time, when he was not working as an aircraft mechanic at Brewster Aeronautical Corporation, in Newark, New Jersey, or as a navigational and engineering draftsman at the Stevens Institute of Technology, in Hoboken. These gouaches are disturbing works, whose horrific images remind one of Jacques Lipchitz's wartime gouaches, a selection of which supplemented his exhibitions at Curt Valentin's Buchholz Gallery in 1942 and 1943. The expressionistic sculpture Lipchitz made after his arrival in New York had a profound influence on Roszak. So did his gouaches, which became an impetus for Roszak's own investigations.

Roszak's gouaches introduce many of the themes—invocation, fertility, hybrid figuration—that characterize his work from the late 1940s until his death. Strutting vaginalike shapes with extended arms (Fig. 23), which recall Lipchitz's *Blossoming I* and *II* (1941-42), *Yara* and *Myrah* (both 1942), evolve into *Invocation I* and *II*. A pair of squat legs, as seen in these gouaches and *Study for "Thistle in the Dream"* (CAT. 123), or the suggestion of an anthropomorphic tripod base, are the first signs of a more overt figuration. And in other images, such as *Study for "Thorn Blossom"* (Fig. 24), the crescent shape—one of the earliest motifs in Roszak's iconography—is transformed within a more expressionistic image. The crescent became one of the most ubiquitous forms in Roszak's work, reappearing in various sculptures, drawings, and prints from 1932 on. The implications of the crescent shape, depending on its context and the way it was handled, changed dramatically.[4]

The gouaches also signify Roszak's return to nature, natural forms, and organic configurations. During the 1930s his rapport with the natural environment had been subordinate to his infatuation with the metropolis. But the gouaches, with their proliferation of fossil and bonelike forms, revert back to nature at a primordial level. "You come up with these references back to nature," Roszak recalled, "because this is what you feel hasn't been making any kind of inroads or developing within the self, and it is a sure way of starting all over again."[5] Starting all over meant finding new ways to express old themes.

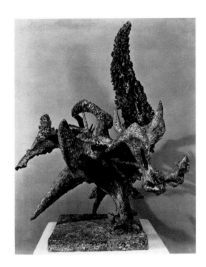

As a result of the war, Roszak reworked certain themes with intense concentration and formal invention.[6] Flight, a central theme, underwent a dramatic metamorphosis in the late 1940s. What had been a positivistic projection in earlier constructions, where chromium finish and streamlined torsos signified a machine-age culture going places, discovering new planets and galaxies, took on more sinister connotations. *Spectre of Kitty Hawk* (1946-47; Fig. 25) is not only a manifestation of Roszak's rage, but his response to the spirit of flight as a death-dealing instrument.[7] Spectre was also an archetypal incarnation of the prehistoric pterodactyl, who prowled the primordial skies terrorizing all life below, as well as a phoenix that rose from the ashes of atomic fallout. These were some of the ways Roszak described *Spectre.* But its identity as a spectral image in which male and female principles are reconciled is more evident in its preliminary drawings.

Roszak recorded his first ideas for *Spectre* in a suite of five graphite sketches on 8-by-10-inch sheets of graph paper (Figs. 26, 27). Never seen during the artist's life time, these explicit renderings make one thing clear: *Spectre* evolved from the image of a man-thing (a typical surrealist motif—half-bird, half-beast) on its knees leaning backward, with a large phallic projection. In some of the drawings, the animal's head is conceived as an elongated beak and in one instance as a cranial orifice, redrawn, as a detail, at the bottom of the same sheet. That Roszak was dealing from the beginning with a figurative entity is reinforced in two sketches by a series of marginal images—totemic and skeletal personages. In each of these sketches, the recurring motif of a projecting phallus supporting smaller crescent shapes intimates the synthesis of masculine and feminine elements in the finished sculpture.

If these five sketches represent *Spectre of Kitty Hawk's* more masculine and militaristic side, another series of ink and wash drawings made about the same time (Fig. 28) embodies its feminine counterpart. In these drawings, the spectre, no longer on its knees, stands upright and defiant, completely exposed. The crescent has uncoiled into a labial slit running the full length of the body and terminating in a barbed tail. The spectre's wings, splayed and scorched as they extend to either side, emphasize the vertical axis that dominates this ferociously feminine image.

The projection and resolution of opposites reflect a dialectical orientation germane to Roszak's way of working. By the early 1940s the psychological dynamics of his work had a strong Jungian inflection. Although he may have encountered Jung's ideas about the anima and animus through Joseph Campbell at Sarah Lawrence College, where he taught in the art department from 1941 to 1955, already by the late 1930s he had intuitively formulated a point of view that reflected similar principles.

Roszak drew phallic images to signify aggressive and death dealing forces, as well as a psychological state struggling for balance and integration. In two studies for *Monument to an Unknown Political*

25. Theodore Roszak
Spectre of Kitty Hawk, 1946–47
Welded and hammered steel
brazed with with bronze and
brass, 40 ¼ x 18 x 15 in.
The Museum of Modern Art,
New York. Purchase.
(Not in the exhibition)

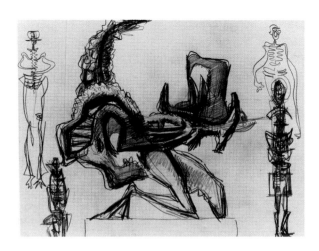

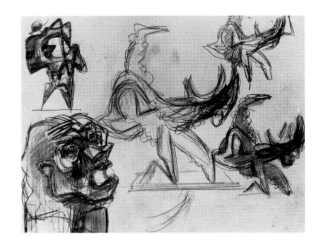

Prisoner (CATS. 117, 118; Fig. 29), he pursued another variation, this time for a potential war memorial.[8] In both drawings the figure is conceived atop an elevated mound, which serves as a kind of base and resembles a launching pad. Some of the earliest studies had an ancient prototype: the Nike of Samothrace, whose massive wing span and airborne posture provided an appropriate symbol for liberation. In these drawings, though, one wing, reversed, becomes the figure's head, a protective shield, and a flaming barrage of metal jetsam. At its lower abdomen appears a phallic extension—barbed and armored—a projectile, a missile, a weapon that strikes out. Wanting to avoid an image that was passive and resigned, incarcerated, and therefore incapable of affirmative action, Roszak gave his figure a phallic spike. In doing so he made its defense its liberation.

The figure stands out as a leitmotif in Roszak's development. It was his fundamental connection to a sculptural tradition, which he saw revitalized through its conflation with surrealist anatomies, mythical themes, and literary sources. Although he also explored more abstract configurations, and a series of "Star Bursts" and "Novas" (PL. IV) are significant for their remarkably intricate execution and as analogues for disintegration, holocaust, and catastrophe, these abstract designs are secondary to more representational images in which the figure is a central proponent. The origins of a monumental figuration can be found in Roszak's late constructions, the 8-foot high "bipolar" forms he fabricated after the war, and in the margins of his earliest sketches for *Spectre of Kitty Hawk,* where the preoccupation with a more totemic and primitivistic personage is already evident.

During the 1950s these possibilities were pursued in a series that began with *Skylark* (1950-51). In two studies (CATS. 113, 114; Fig. 30), Roszak developed the basic anatomy for a life-size personage whose flailing extremities and fragile constitution reflect an inherent dilemma: a desire for flight but an inability to rise. In both drawings the figure is stripped to its skeletal core. Its deformed features, especially its emaci-

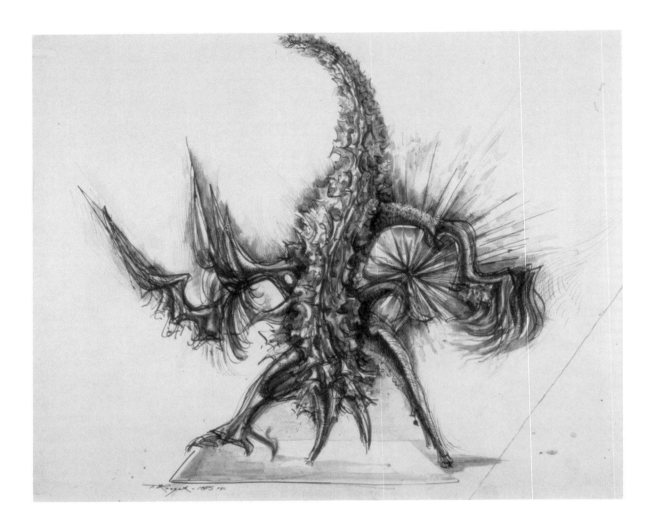

ated abdomen, spindly legs, and hooked feet preoccupied Roszak in his preliminary conception of the piece. Based on a poem by Gerard Manley Hopkins, *Skylark* was described by Roszak as an archetypal entity, "like Icarus in flight and his downfall....his constant rise and fall, very much like Sisyphus in the process of doing it all over again....a Christ figure and a devil." [9] In another interview, he described the sculpture as "Mephistophelian" and "Promethean," as "man descended from his Promethean heights, captivated within the bonds of civilization, and reduced to the ashes of his own bones, a very powerful allusion to the spiritual plight of man." [10]

What united Icarus, Sisyphus, Mephistopheles, Prometheus, and Christ, in Roszak's mind, was their heroic and tragic nature; they were all entrapped between heaven and earth, the spiritual and the corporeal. One could also see *Skylark* as the mythic counterpart to Albert Giacometti's postwar effigies, particularly his *Man Pointing* (1947), which Roszak saw exhibited at the Pierre Matisse Gallery in 1948. There is the same sense of fragility and vulnerability, ambivalence and tension, morbidity and destitution. Giacometti conceived of the figure—whole or partial—as a

28. Theodore Roszak
Study for "Spectre of Kitty Hawk," 1945
CAT. 110

48

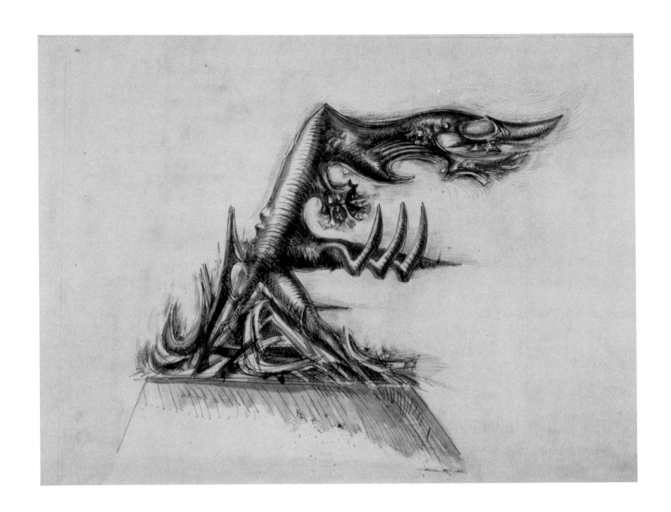

battleground of perceptual forces. Although such an approach was not entirely new to Roszak, Giacometti's conception offered him a sculptural analogue for a phenomenological condition: the figure stripped to its essential being; the figure as a spiritual and psychological casualty; a victim of political circumstances; a personage existing somewhere between being and becoming, physicality and dissolution.

The drawings for *Skylark,* one series among the many figurative images Roszak executed during the 1950s, epitomize his postwar sensibility. They are an amalgam of personal and collective experiences; they reflect a cross-fertilization of ideas—from mythology and literature to poetry and anthropology—and a comprehensive overview of art, seen as a continuum extending backward and forward; and they reaffirm the primacy of the psyche as the ultimate source of visual ideas. Roszak, like other sculptors in this exhibition, set out after the war to revitalize monumental figurative sculpture. The new figuration, however, had a disquieting edge and posed difficult questions. It also challenged sculptors to find ways of combining abstraction and representation without compromising the work's humanism and formal integrity.

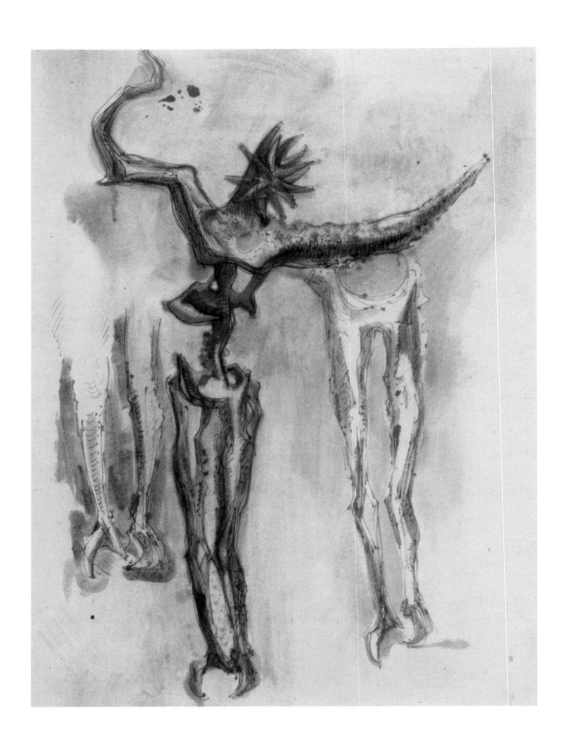

30. Theodore Roszak, *Studies for "Skylark,"* 1950-51. CAT. 114

NOTES

1. Theodore Roszak, "The New Sculpture Symposium," February 12, 1952, transcript, The Museum of Modern Art, New York, p. 16.

2. Harlan B. Phillips, "Theodore Roszak Reminisces: As Recorded in Talks with Dr. Harlan B. Phillips," 1964, transcript, pp. 1-15. Theodore Roszak Estate.

3. Roszak included some of his first gouaches in Dorothy C. Miller's 1946 "Fourteen Americans" exhibition, listed in the catalogue on p. 79, no. 24, as *Studies for Sculpture*, 1945-46; and later in his 1956-57 Walker Art Center retrospective, listed in the catalogue on p. 50, nos. 54-56, as *Carcass, Frost-Covered Rocks*, and *High Altitude*, all of 1947.

4. Roszak saw the crescent as embodying the kind of significance that animated all form. Its origin was twofold, relating on the one hand to the crescent moon that bears the Virgin as a sign of her Immaculate Conception, and, on the other, to the essential shape of a microscope or an astronomical instrument, such as a ring dial. During the 1930s, the half-moon, C-shaped configuration signifies what is essentially Constructivist, technological, and geometric. In later postwar works, it is more anthropomorphic, a female principle, a concave pocket, a passive receptor, a yielding shield that receives rather than deflects. The crescent shape could be both male and female, projective and recessive, aggressive and passive; it could encompass a vast terrain, from the microscopic world of cellular biology to the extraterrestrial world of stars and planets; see Douglas Dreishpoon, "Theodore Roszak (1907-1981): Painting and Sculpture," Ph.D. dissertation, City University of New York, 1993, chap. 2.

5. Phillips, "Theodore Roszak Reminisces," pp. 388-89.

6. The iconographic parameters of Roszak's sculpture, which were fairly well established by the mid-1950s, are discussed in detail in Joan Seeman Robinson, "The Sculpture of Theodore Roszak: 1932 1952," Ph.D. dissertation, Stanford University, 1979.

7. Robinson 1979, pp. 102-08, discusses the affinity of Roszak's *Spectre of Kitty Hawk* with contemporary war planes and primordial beasts.

8. *Monument to an Unknown Political Prisoner* was selected, in 1953, as one of nine finalists to represent the United States in an international competition sponsored by the Institute of Contemporary Arts in London. The 22-inch maquette was subsequently bought by The Tate Gallery for its permanent collection.

9. Phillips, "Theodore Roszak Reminisces," pp. 472-73.

10. James Elliott, "Interview with Theodore Roszak," February 15, 1956, transcript, Archives of American Art, Smithsonian Institution, Washington, D.C., p. 74.

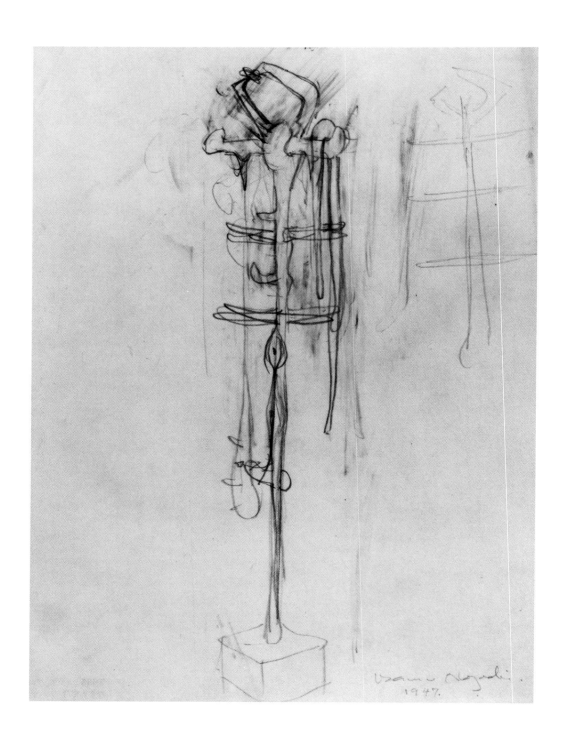

32. Isamu Noguchi, *Study for Sculpture*, 1947. CAT. 99

ISAMU NOGUCHI

The first thing one notices about Isamu Noguchi's drawings for sculpture is their diminutive scale; most of the works selected for this exhibition do not exceed 11-by-14 inches. Noguchi approached drawing as an intimate dialogue with himself, a simple practice without monumental expectations.[1] Some drawings focus on a central image; others develop an idea in serial variations. Many drawings were left unsigned. He often worked on both sides of a sheet, covering each with the most unassuming and abbreviated notations. His line could be dense and agitated, delicate and light, sometimes to the point of seeming hesitant. He preferred the unpretentious medium of graphite, and seldom supplemented his initial notations with other media. Graphite suited his sensibility. He probably liked the fact that it could be erased and that its afterimage produced a ghost effect. The ability to erase meant that nothing was indelible and yet all changes were recorded. Noguchi's drawings speak in whispers. They are mental projections that complemented his empirical encounters with sculpture.

In one of the earliest drawings in the exhibition (Fig. 31), which contains two studies (recto and verso) for *Monument to Heroes* (1943), Noguchi explored the idea of a monument as a hollow cylindrical column whose surface is pierced by numerous apertures through which various forms protrude. These sketches offer no indication of scale, or the actual materials used in the final piece. They do, however, suggest a monolith violated through puncture and projection. (*Monument to Heroes* is dedicated to the senseless deaths caused by war.) They also intimate, and this is reinforced by two other sketches on the same sheet, *Studies for "Bell Tower for Hiroshima"* (1950), and another drawing, *Study for "The Gunas"* (1946) (CAT. 96), Noguchi's preoccupation with forms balanced within vertical scaffoldings. In the final sculpture, found objects consisting of bones from the attic of the Museum of Natural History and propeller-shaped pieces of wood are held in suspension by a series of guy wires that traverse the cylinder. The creation of tension through dynamic equilibrium is a significant aspect of Noguchi's postwar orientation.

Noguchi entered the 1940s encouraged by science and technology as agents of progressive change. Between his earlier apprenticeship, in 1926-27, to Constantin Brancusi and subsequent friendship with Buckminster Fuller, whom he met in 1929, Noguchi developed a comprehensive worldview in which the past, present, and future were seen as a continuum. His was a cosmology that acknowledged grand cycles and

31. Isamu Noguchi
*Studies for "Monument to
Heroes" and "Bell Tower for
Hiroshima,"* about 1943–50
(recto and verso)
CAT. 87

space as a ubiquitous buffer uniting all things. But World War II, which brought personal hardships for Noguchi, who elected to live for six months in a relocation camp at Poston, Arizona, threw shadows across any kind of utopian pretension. Forced to reassess many of his former beliefs, he gravitated toward sculpture that reaffirmed atavistic values and a fragility that characterized contemporary life. What had been a preoccupation with portraiture before the war, with a realism based on an individual's idiosyncratic features, became an exploration of the body as an anonymous and fragmented entity.

One sees this transformation played out in the drawings, where the figure is conceived as a precariously balanced assemblage. Noguchi's personages seem vulnerable. Their biomorphic configurations, what the sculptor traced back to traditional Japanese calligraphy, also recall Yves Tanguy's painted landscape markers or some of Matta's fierce totems (Figs. 32, 33). In certain drawings (CATS. 93, 94; Fig. 34) a flat, shieldlike plane is violated by sharp projections that rip through it. What distinguishes these works is the contrast between protective and aggressive, nurturing and threatening elements within an ensemble teetering between consolidation and collapse.

The many granite, slate, and marble personages Noguchi created between 1942 and 1948 constitute one of the most coherent aspects of his work. When these notched beings were first shown, people were intrigued with the way they could be easily assembled and disassembled. In fact, this aspect of their design was highlighted in a *Life* magazine article published in 1946.[2] Apparently, such a feature made good copy, but it had quite another significance for Noguchi, who adamantly embraced traditional methods, such as carving, when other sculptors were experimenting with industrial techniques, such as welding and brazing with an oxyacetylene torch. Although the disjunctive quality and biomorphic

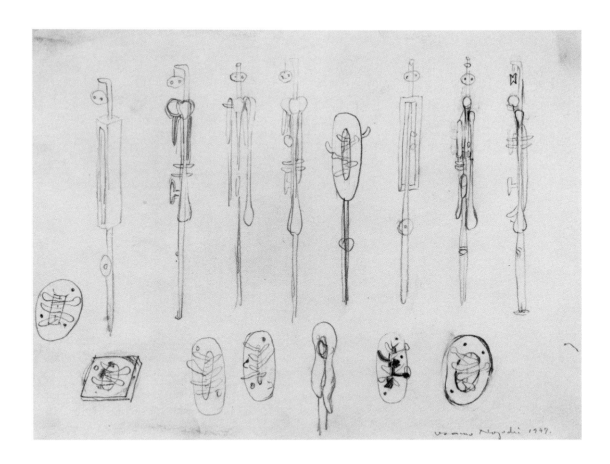

33. Isamu Noguchi
Fifteen Studies for Sculpture, 1947
CAT. 98

character of Noguchi's drawings have an affinity to contemporaneous works by Herbert Ferber and David Smith, his constructional methods differ considerably. For Noguchi, a return to basics, though it encompassed some of the same primordial objectives, meant using techniques and materials that themselves affirmed a timeless tradition. His decision to carve stone, what he described as the earth's bones—its history—was a way to retain the integrity of his material without altering its appearance through casting, welding, or painting.

Noguchi's personages are like biomorphic puzzles, whose forms were often conceived through drawing. On larger sheets of graph paper (CATS. 88–90; Fig. 35, PL. V), Noguchi plotted out a lexicon of Euclidean shapes. Those that interested him the most were cut out, saved, and sometimes made into maquettes. What remained were the negative spaces, or ghost images, overlaid against black paper. As templates for form, these graph-paper cutouts affirm the importance of biomorphism in Noguchi's postwar conception.

Noguchi believed the sculptor to be someone who ordered, animated, and gave space meaning. Growth and transformation were essential aspects of his philosophy; they helped the human psyche accommodate chaotic circumstances. He not only wanted his work to suggest the

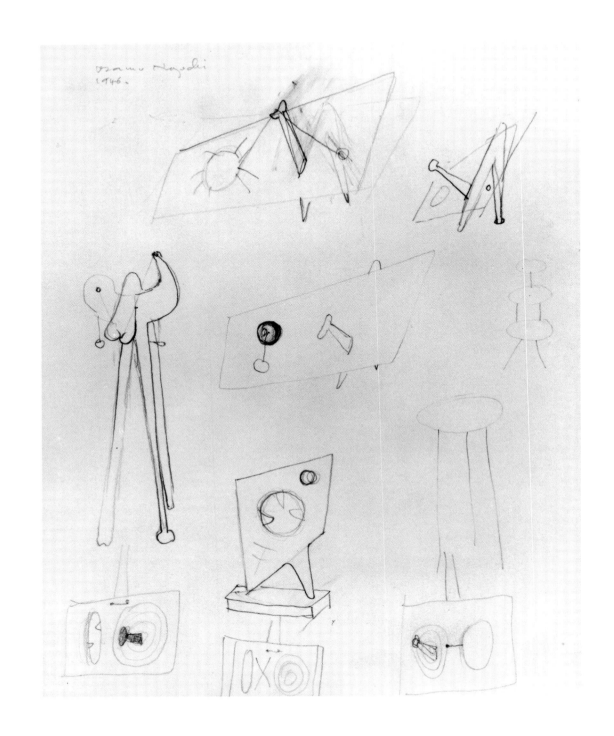

34. Isamu Noguchi, *Ten Studies for Sculpture (including "Avatar"),* 1946. CAT. 93

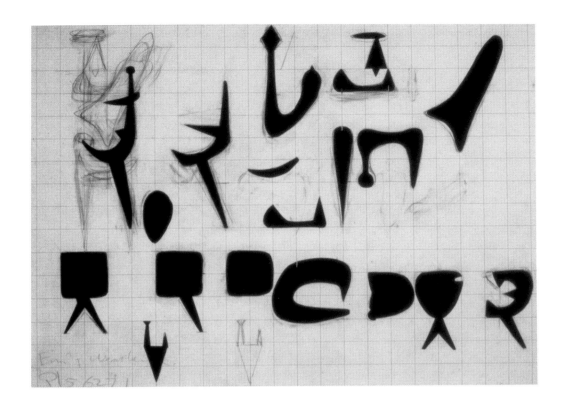

35. Isamu Noguchi
Worksheet for Sculpture,
about 1945–47
CAT. 90

transience of existence, but to take its place within a greater spatial continuum, be it public parks, gardens, or the "hypothetical space" of the theater. He once described his postwar sculpture as "transformations, archetypes, and magical distillations."[3] For him, they were metaphors for a universal condition. Biomorphism appealed to Noguchi because it acknowledged the irrational, the realm of dream, and its amorphic forms signified systems in flux. Noguchi's biomorphism may have a noticeable affinity to work by Joan Miró, Matta, Tanguy, and Arp, but his iconography was inflected by his own experiences and cultural background. Look again at the graph-paper cutouts. Some of the shapes are derived from Japanese bells, samurai swords, and half-moons; others resemble figures dancing.

The extent to which Noguchi pursued biomorphic imagery during the 1940s was sustained through collaborations with the dancer Martha Graham, a kindred spirit who fervently believed in collective continuity and the ritualistic function of art. Graham's recommendations for a particular set often developed around an informal exchange of ideas based on a given theme or narrative. Noguchi's designs were, in part, the product of these discussions, and it is conceivable that many of the sculptural elements that made up his designs originated on graph paper and provided the specifications for a maquette which was then enlarged in wood, stone, or magnesite. *In situ*, these objects were animated by Graham and her dancers. Discussing his earliest work with Graham,

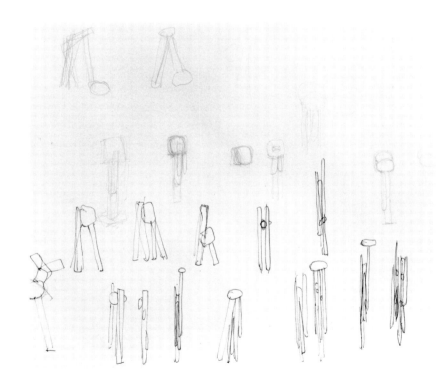

36. Isamu Noguchi
*Two Studies for Sculpture
(including "The Cry"),* 1957
CAT. 104

37. Isamu Noguchi
*Twenty-five Studies for
Sculpture (including
"Mortality"),* about 1955-59
CAT. 106

Noguchi later remarked: "It was my wanting to know what sculpture could do in space, what it had done, what it was in space in former days, how it related to peoples' ceremonial view of life." [4] For Noguchi, the word ceremonial not only had spiritual connotations, but it referred to sculpture whose formal integrity was inseparable from its metaphorical associations.

Noguchi is best known as an abstract sculptor. His notion of abstraction, however, was neither exclusively formal nor entirely non-representational. His incorporation of organic and geometric forms was a way of evoking the analytical and intuitive aspect of human nature. During the 1950s, as he moved beyond the anthropomorphic focus of his wartime personages, he retained the tension implicit in these earlier works through clustered configurations that defy gravity. Several drawings from this period, studies for *The Cry* (1959-63) and *Mortality* (1959), are projections of the most humble sort that imply a communal gathering around a common source. In studies for *The Cry* (Fig. 36), six rectangular elements encircle a headlike shape positioned atop a vertical shaft. In another variation on the same sheet, the arrangement is more helter-skelter. The multiplicity of forms in these studies is distilled, in the final sculpture, down to a single vertical shaft supporting a pierced elliptical orb to which one element connects at a tangent. Noguchi conceived *The Cry* as a singular emission, abstracted tear, or distraught being caught off-center.

The many studies for *Mortality* (Fig. 37) develop around rectangular clusters descending from a headlike block. If mortality implies death in numbers, then such an image is a poignant metaphor expressed here through the simplest of means. Certain sketches on this sheet are reinforced with pen and ink, as though Noguchi were attempting to shore up their definition. The results, however, remain as insubstantial as the theme they represent.

NOTES

1. Noguchi did execute monumental drawings during his life time, such as a series of figurative brush drawings in the early 1930s while he was studying with the Chinese master Chi Pai Shih, in Peking. When it came to his sculpture, however, most studies were unpretentious notations and serial projections.

2. *Life*, November 11, 1946, p. 13. The article appeared simultaneously with Dorothy C. Miller's "Fourteen Americans" exhibition at The Museum of Modern Art, which included about four of Noguchi's stone personages.

3. Isamu Noguchi, *A Sculptor's World*, (New York: Harper & Row, 1968), p. 29.

4. Paul Cummings, "Interview with Isamu Noguchi," December 18, 1973, transcript, Archives of American Art, Smithsonian Institution, Washington, D.C., p. 87.

40. Louise Bourgeois, *Femme Maison*, 1947. CAT. 5

LOUISE BOURGEOIS

For Louise Bourgeois, drawing has always been an unpretentious affair. During the 1940s and 1950s she often drew with whatever materials were available—pens, pencils, charcoal, colored inks—on smaller sheets of paper that varied in quality from artists' standard stock to low-grade pulp. Her graphic production has always been sporadic, depending on her mood and circumstances. "I get hooked on a subject and I make sketches and drawings," she told Donald Kuspit. "It means the obsession is going to last for several months. Then it will disappear and reappear several years later." [1] Drawing provided easy access to the subconscious, a means of initiating ideas and stockpiling the results.

Bourgeois' postwar drawings mark a preoccupation with metaphor and innuendo, with an imagery veering toward abstraction and expressing ongoing conflicts—between a public and private self, past and present, dream and reality. Her line can be jagged and staccato, graceful and refined. Some times it seems weighty and ponderous; other times light and delicate. She tended to prefer the crisp stroke of a pen to the broader swath of a brush. Lines coalesce to define form that resembles strands of fabric or hair, both of which assumed a personal significance. [2] In the majority of Bourgeois' drawings, line is primary, the essence of an image, whether a solitary figure whose contoured features dominate an entire sheet, a fantastic landscape, or a gathering of bulbous pods.

In many of the early drawings it is hard to separate an imagery of ambivalence and alienation from personal events in the artist's life. Bourgeois' first years in America, after moving from France to Connecticut with her art-historian husband Robert Goldwater, were a difficult time of adjustment. She missed family and friends and had not yet acclimated to American culture. When Bourgeois arrived in America at the age of twenty-seven she still considered herself a painter. It was not until several years later, after two one-person exhibitions, that she seriously took up sculpture, a medium whose tangibility better suited her sensibility. During the course of this transition, drawing provided an immediate outlet for many of her ideas.

One of the earliest works in the exhibition, an ink sketch on gray paper (Fig. 38), depicts several heads scattered across a landscape or seascape. Like bobbing buoys amid a vast ocean, the personalities inhabiting this mindscape symbolize distant memories separated by space and time. Another image from this period (CAT. 2), also rendered on

colored paper, suggests the sadness of separation and the difficulty of taking leave. Tears emanating from closed eyes become life lines to a fleeting past, perhaps to loved ones far away and no longer part of her daily life. Such images, childlike in their simplistic execution, recall other "nostalgia pictures" that Bourgeois painted during this time. What is interesting, though, is her use of the landscape, a motif that reappears in many of the later drawings. Early on it functions as a nondescript terrain, a buffer between people, and a foil for the projection of recollections. Later, its swells, referring to the body as well as geography, become the organic substratum from which form germinates (Fig. 39)

One of the most disturbing and yet intriguing images to appear during the late 1940s is the "Femme Maison." Being an ambitious artist who was also married and had three young sons, Bourgeois felt the weight of responsibility, which she grappled with in her art. Domestic subjects were a standard part of her repertoire by the late 1930s; a number of thumbnail sketches, for example, depict men and women interacting within homey interiors.[3] But such scenes seem benign compared to a single-story ranch house elevated on a precarious perch (CAT. 4) or a woman's body transformed into a multileveled structure. In one of her most memorable drawings, Bourgeois depicted a female torso as an elongated rectangular box barred at the bottom, closed off at the top, and completely exposed in the middle (Fig. 40). Two legs emerge from the

38. Louise Bourgeois
Untitled, 1943
CAT. 1

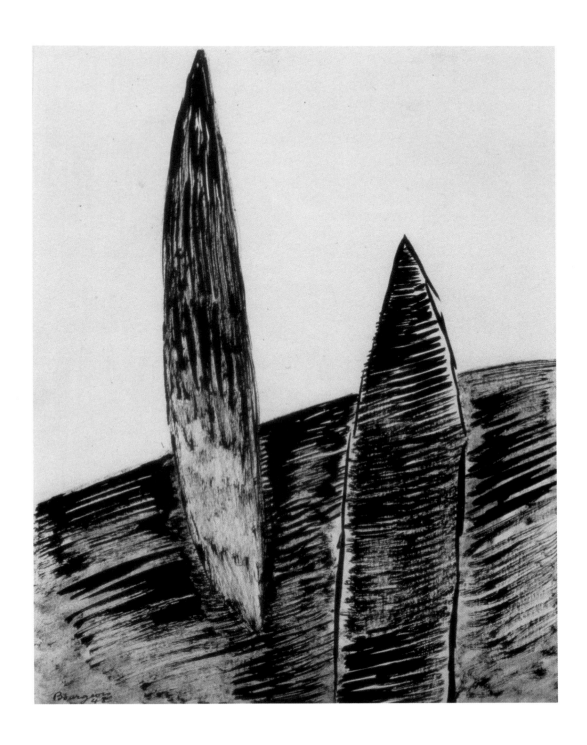

39. Louise Bourgeois, *Untitled*, 1948. CAT. 10

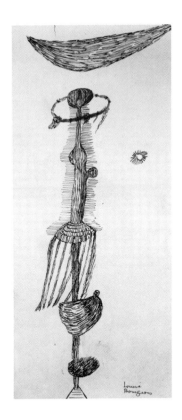

bottom, an arm from top right, the whole surreal image enveloped in effusive skeins of hair. The "Femme Maison" had a number of variations, which developed around the notion of confinement: a domicile grafted to a figure's upper torso or made into its entire body, except for pairs of legs and arms protruding from either side. What is so troubling about this particular drawing is its exposed abdomen. The house has become the figure's body and the body lacks a center.

The absence of a center in postwar figurative sculpture came to have existential implications. The void signified the unknown, spiritual death and artistic stasis, and one's internal struggle with such things took on heroic overtones. In Bourgeois' art, the void shared a collective dimension, but it also had a personal inflection. If the house had become a cage that stifled artistic growth, the void symbolized her ambivalence. But the void had another significance for Bourgeois, who mentioned it during the three-day "Artists' Sessions" held in 1950 at Studio 35 on Eighth Street. "I try to analyze the reasons why an artist gets up and takes a brush and a knife—why does he do it?," she asked. " I feel it was either because he was suddenly afraid and wanted to fill a void, afraid of being depressed and ran away from it, or that he wanted to record a state of pleasure or confidence, which is contrary to the feeling of void or fear. My choice is made in my case, but I am not especially interested in talking about my own case." [4] When it came to assessing the creative act, Bourgeois avoided personal motivations. But as one of the only women, along with Hedda Sterne, at these historic sessions, her perspective would seem to reflect her own circumstances. By way of defining "genesis," or the process of creation, she asked, "Is it the process of being born or the process of giving birth?" [5] Given the way other, male participants addressed this same question, Bourgeois' gender-specific point of view was anomalous. She domesticated the creative act, that existential encounter with the unknown, and in doing so gave its heroic persona a completely new identity.

Bourgeois' maverick nature set her on a solitary path when it came to associations with either European Surrealists or American Abstract Expressionists during the postwar period. A self-proclaimed outsider, she was intolerant of André Breton's patriarchal proclamations and the group's passive-aggressive attitude toward women. Though no stranger to Surrealism, its fascination with the marvelous, the mind, and multivalent imagery, she rejected its sexual politics.[6] And the underlying politics of a "modern man" discourse, the ideological basis for the burgeoning New York School, were no better, given their inherently exclusionary bias.[7] Bourgeois' virtue was her ability to remain aloof without relinquishing her position on the fringe. Working in relative isolation, she created art in response to her own experiences as a woman and mother.

For all this dogged individualism, many of Bourgeois' drawings grapple with the dialectical tension between isolation and integration, hermeticism and socialization. Discrete forms clustered around a central

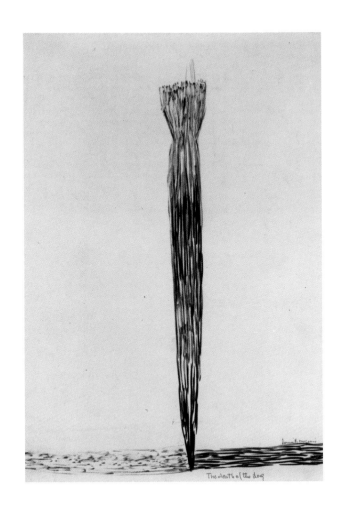

core (CAT. 19) or rendered suspended from above (PL. VI) are antithetical counterparts to a single personage posed alone. While Bourgeois, in a drawing on colored paper from 1946 (Fig. 41), conceived of the figure as an embellished totemlike maypole full of pomp, most of her personages are lean. *Death of the Dog* (Fig. 42) is a good example. Stripped to its essential skin, this kind of unitary presentation recalls the many carved figures that populated her first installations at the Peridot Gallery in 1949 and 1950. At the same time that drawings became a more integral part of these exhibitions, they also set the tone for more ambitious pieces composed of multiple elements.

In numerous works from the late 1940s, Bourgeois took the idea of a compacted ensemble, what later became the basis for *Forêt (Night Garden)* (1953) and *One and Others* (1955), and inverted it. "Horizontality is a desire to give up, to sleep," she wrote. "Verticality is an attempt to escape. Hanging and floating are states of ambivalence."[8] Like suspended sacks of meat or cocoons, these dangling pods seem especially vulnerable. That they constitute a group is no consolation given their orientation.

42. Louise Bourgeois
Death of the Dog, 1950
CAT. 18

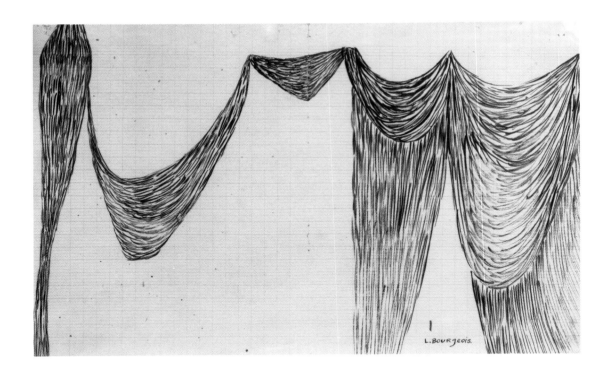

Bourgeois described her work as "symbolic geometry." Certainly her study of mathematics early on at the Lycée Fénelon, and subsequently at the Sorbonne, had a profound impact on her perception of sculptural form. For many sculptors, the study of topology (that branch of mathematics dealing with geometric configurations, their deformation and manipulation) is germane. For Bourgeois, mathematics provided a system through which form could be conceptualized. It signified a discipline of order, the antithesis of pure intuition—the stuff of dreams. Topology was to Bourgeois what Constructivism was to David Smith, Theodore Roszak, and Isamu Noguchi: a rational model that offered definitive answers to difficult questions, a way of illuminating the darker corridors of the unconscious through programmatic procedure.

Given her interest in Euclidean geometry and self-contained systems, it is not surprising that Bourgeois worked out some of her ideas for sculpture on graph paper, where any impulse could be realized according to the coordinates of an axial grid. In one graph-paper drawing from 1949 (Fig. 43), a series of veil-like forms unfurl across the sheet. Inseparable and yet precariously linked, they create a kind of screen, a protective barrier. In another drawing from 1950 (Fig. 44), a convoluted sphere implodes on itself. What seems extended and exposed in the graph-paper drawing is consolidated and withdrawn in the other. A topological configuration composed of many complex, overlapping curves, the knot is a poignant metaphor for a dysfunctional condition. For Bourgeois, it may have signified a seizure of creativity, or embodied negative forces to be feared, perhaps even more than death.

43. Louise Bourgeois
Untitled, 1949
CAT. 11

66

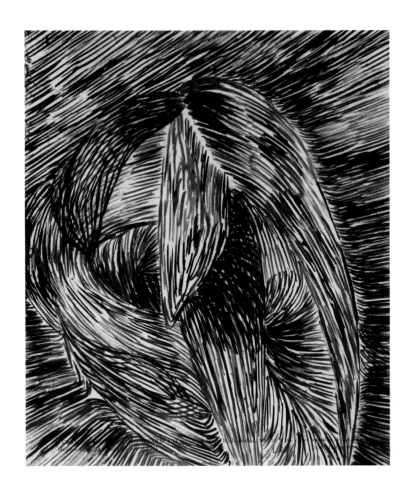

NOTES

1. Donald Kuspit, *Interview with Louise Bourgeois* (New York: Vintage Books, 1988), p. 45.

2. Bourgeois' family owned a gallery and workshop that specialized in the sale and restoration of tapestries. As an adolescent, she assisted in the tapestry workshops by making drawings. Hair, a recurring motif in many of her postwar drawings, had numerous implications and personal inflections; see Robert Storr, "Intimate Geometries: The Life and Work of Louise Bourgeois," *Art Press*, 175 (December 1992), p. E3.

3. Some of these are reproduced on microfilm; see Louise Bourgeois, Archives of American Art, Smithsonian Institution, Washington, D.C., roll 90.

4. Quoted in *Modern Artists in America*, eds. Robert Motherwell and Ad Reinhardt (New York: Wittenborn Schultz, 1951), p. 15.

5. Ibid., p. 17.

6. Bourgeois' relationship with the French Surrealists who lived in New York during War World II was reserved and distant; see Storr, "Intimate Geometries," pp. El-E5.

7. For a provocative discussion of gender and subjectivity within a "modern man" discourse, see Michael Leja, *Reframing Abstract Expressionism: Subjectivity and Painting in the 1940s* (New Haven: Yale University Press, 1993), pp. 253-68.

8. Louise Bourgeois, quoted in *Louise Bourgeois Drawings*, exh. cat. (New York: Robert Miller Gallery, 1988), p. 109.

44. Louise Bourgeois
Untitled, 1950
CAT. 16

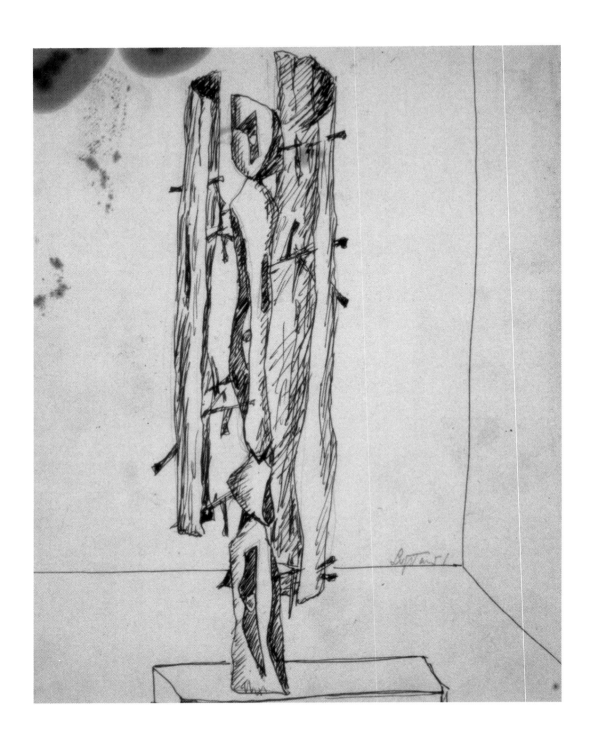

51. Seymour Lipton, *Study for "The Cloak,"* 1951. CAT. 74

Seymour Lipton

During an interview with Dorothy Seckler, Seymour Lipton reminisced about drawing in the form of an amusing story. He recounted how, as a boy of about twelve, he used to draw after dinner while the rest of the family sat around playing cards and talking.[1] This would go on for some time until his mother, in a concerned tone of voice, would tell him to stop what he was doing. "Go to bed," she'd say. "You'll hurt your eyes, don't draw." Obviously, even as a young boy Lipton loved to draw, and the opportunity to continue, during the late 1920s, as a student of dentistry probably seemed like a stroke of good fortune. Lipton, like Ferber, came to art through a medical program that offered, as part of its core curriculum, courses in anatomical rendering. With a knowledge of the body's internal and external anatomy, Lipton eventually pursued a more radical approach: an abstracted figuration that moved beyond sociopolitical commentary into the realm of myth and metaphor.

What came to preoccupy Lipton from the late 1930s until his death was a conception that acknowledged the underlying humanism of traditional Western sculpture but stretched, even violated its canons of beauty and perfection. He wanted his work to be contemporary, to function dialectically, as a forum for opposing principles—male/female, life/death, organic/technological. Abstraction enabled him to wrap natural forms into multivalent configurations. A "non-anatomical humanism" was the term Lipton coined to describe an aesthetic that drew from various sources—the tortured forms in Hieronymus Bosch's painting, pre-Columbian, Cycladic, Oceanic, and African sculpture—in an attempt to revitalize figurative art. "The human gesture and the human figure is very limiting in its possibilities," he said, "whereas non-anatomical suggestions of the human presence can offer the possibilities of wide areas of feeling, form, and experience, which largely impinges on the realm of poetry, especially dramatic poetry, in its suggestion and relation to the use of metaphor, the formal metaphor, the plastic metaphor—forms suggestive of nature and of man but not actually showing man." [2]

Through drawing Lipton recorded his first sculptural impulses and worked through their formal variations. The drawn image had a very specific place in his creative process, as the first step in a three-step progression; the second step was a small maquette, which lead to a large-scale, welded and brazed sculpture. There is a certain predictability to these drawings; they do not extend the medium or take chances in the

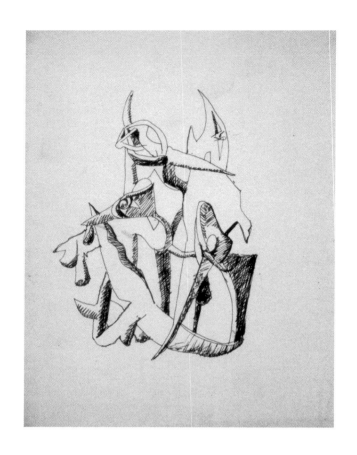

same way drawings by Smith, Ferber, Dehner, or Roszak do. Lipton, it seems, saw drawing primarily as an expedient means of investigating an idea's formal extensions. Time and time again he developed the permutations of an image in a series, using the same size paper (usually an 11-by-8½-inch sheet of typing bond), pencil or ink (in earlier drawings), conté crayon (after about 1951), and a format in which each sculptural motif is rendered against a stark background articulated by a single horizon line or several perspective lines that suggest an interior space. Strong contours delineate most configurations. While earlier drawings are filled in with cross-hatching, in later conté crayon works, subtle modeling is used. In their emphatic emphasis on a discrete image, Lipton's drawings offer a nuanced record of an idea's sequential development.

Many drawings are analogues for struggle and confrontation, order and chaos. An early untitled work from about 1945 (Fig. 45) also signals a renewed interest in atavistic roots. Like other sculptors of his generation, Lipton frequented the Museum of Natural History, whose elaborate displays offered a gateway beyond civilization to a primordial past. Amidst these vast collections, and among the manicured beds of the Bronx Botanical Gardens, Lipton discovered a host of new forms—thorns, bones, tusks, teeth, buds, insects, flowers, leaves—that became the basis for a disquieted conception.

45. Seymour Lipton
Untitled, about 1945
CAT. 64

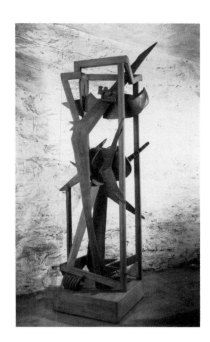

46. Seymour Lipton
Imprisoned Figure, 1948
Wood and sheet-lead
construction,
84¾ x 30⅞ x 23⅝ in.
The Museum of Modern Art,
New York. Gift of the artist.
(Not in the exhibition)

Entrapment and incarceration characterize a series of drawings of an imprisoned figure within a rectangular frame. Most of the sketches around this idea are failed attempts at making a dismembered figure visually compelling in a constricted context. There is no continuity; the frame seems too elongated, the figure too fragmented and extended. In several drawings, however, which became the prototypes for a maquette and finished sculpture (Fig. 46), the figure is rendered as a bow-shaped form that bridges the entire cage (Figs. 47, 48). It struggles for liberation, as it projects beyond the upper extension of the cage, yet its inclined posture also suggests resignation.

The figure conceived within a cage aswirl with secondary and tertiary forms was an apt metaphor for chaotic forces that threatened the order of things. Inherently architectonic, the cage, or frame, provided a stabilizing context, a dimensional chamber or "space cage" for the projection of sculptural form.[3] From the time such a device first appeared as a prominent element in Giacometti's *Cage* (1931) and *Palace at 4 A.M.* (1932-33), and through the 1940s and 1950s, its possibilities were explored by many American sculptors. Some of Ferber's animated calligraphs were conceived within cages and his notion of "roofed sculpture" was decidedly architectural; Noguchi constructed a simple bifurcated frame for *Lunar Infant* (1944) and a more elaborate scaffolding for *Bell Tower for Hiroshima* (1950); Smith used a rectangular frame for *The Hero's* torso, to enclose sculptural elements in *Head as a Still Life* (1940), *Widow's Lament* (1942), and *The Letter* (1950), and to suggest internal chambers within more narrative tableaux, such as *Interior for Exterior* (1939) and *Cathedral* (1950), both as a pictorial reference and a way to isolate and compact form. The extent to which the cage, coupled with biomorphic references, appeared in many sculptors' work during the postwar period led Clement Greenberg to write, "It is symptomatic of more than a local situation that modernist sculpture in America should have succumbed so epidemically to 'biomorphism,' and that then, after all the decorative improvising of plant, bone, muscle and other organic forms, there should have come such a spinning of wires and such a general fashioning of cages—so that the most conspicuous result of the diffusion of the use of the welding torch among American sculptors has turned out to be garden statuary, oversized *objets d'art* and monstrous costume jewelry."[4]

Greenberg's assessment, though intended as a critique of Surrealism, particularly its preference for fantastic and hybrid imagery, underscored the degree to which anthropomorphic and biomorphic tendencies proliferated in postwar American art. Lipton's drawings are full of organic and somatic inflections, and the same could be said of Roszak's, Bourgeois', Ferber's, and Noguchi's. References to germination, growth, and transformation abound in drawings such as *Study for "Germinal II"* (Fig. 49), an untitled work from about 1949 (CAT. 69), and *Study for "Earth Forge II"* from about 1953–54 (Fig. 50). But such references coexist with

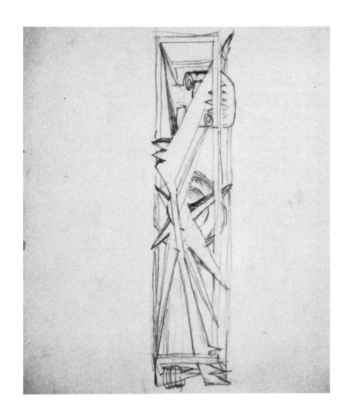

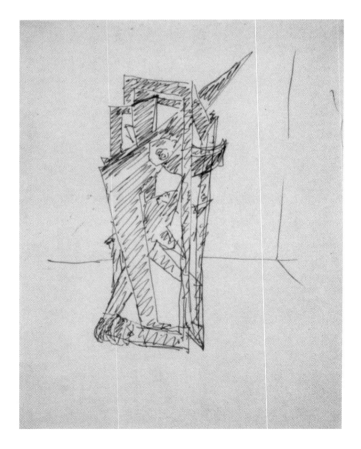

47. Seymour Lipton, *Untitled*
(Study for "Imprisoned
Figure"), about 1948
CAT. 67

48. Seymour Lipton, *Untitled*
(Study for "Imprisoned
Figure"), about 1948
CAT. 68

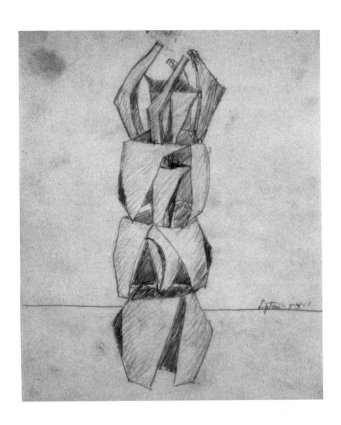

forms implying something more technological. According to Lipton's dialectical scheme, antithetical forces existed in an anxious state of equilibrium. The image of a geometric cube whose interior bulges with a growth that splits its seams; a vertical, plantlike form encased in an armorlike sheathing, or the hybrid, techno-organic character of an earth forge were symbolic representations of this bipolar condition.

Like other postwar sculptors, Lipton gravitated toward the hero as a sculptural theme. While he had always sustained an interest in the vertical figure, after reading Joseph Campbell's *The Hero with a Thousand Faces* (1949), this figure assumed a new focus. Campbell's written accounts of the hero's many incarnations—his struggle with adversity, transformation, and ultimate rebirth—fueled Lipton's imagination by providing a trope that dovetailed with his pursuit of non-anatomical humanism. What Lipton later called his "variations on the odyssey of the life of the hero" began with a suite of drawings, each one addressing a different aspect of the hero's character.

In Lipton's mind, the heroic figure signified courage, the power to conquer adversarial forces. However, one of his first variations, a study for *The Cloak* (Fig. 51), appears introverted and self-effacing. This segmental personage stands upright, flanked on either side by shieldlike forms whose surfaces are pierced by spikes. Its torso has gaping holes, revealing its interior. The contrast between interior and exterior had metaphorical implications in Lipton's work. In this case, the figure's

49. Seymour Lipton
Study for "Germinal II," 1953.
CAT. 77

73

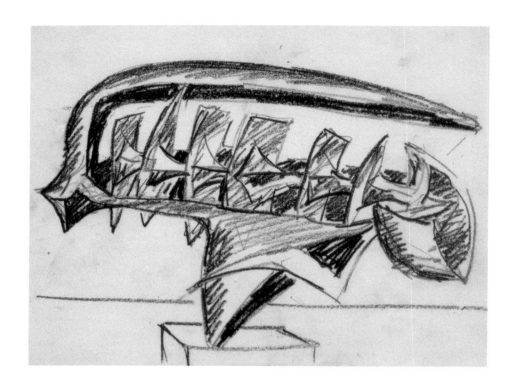

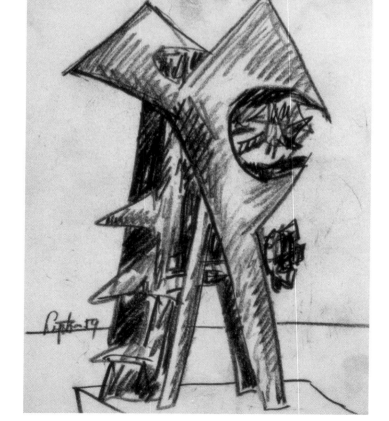

50. Seymour Lipton
Study for "Earth Forge II,"
about 1953-54
CAT. 76

52. Seymour Lipton
Study for "Prophet," 1959
CAT. 85

exposed interior, what the artist described as "the inner secrets of the human soul, of the human psyche," signified its vulnerability. Here was an image having more to do with frailty and concealment then empowerment and aggression.

A very different kind of hero emerges in sketches for *The Prophet* (Fig. 52). Given the piece's belligerent stance and prickly demeanor, one immediately thinks of Old Testament prophets, such as Jeremiah and Ezekiel, who delivered apocalyptic visions with wrathful scorn. In these studies, the figure is conceived around two criss-crossing struts, one carrying sharp projections, two conical caps for its head, and a recessive void (perhaps its mouth), which contains an exploding bud. The hero as vengeful warrior, armed and ready for battle, also preoccupied Lipton in other studies for *The Hero* (CATS. 81, 82; PL. VII). In one version, the figure's torso resembles a plant whose upper extension supports a cranial-like mechanism. The head is the most prominent feature of both *The Prophet* and *The Hero,* and its identity is a cross between a battering ram and a medieval shield. An archetypal entity of many incarnations, the hero not only embodied the perpetual transformations of the human condition, but epitomized its longevity as a figurative trope.

Notes

1. Dorothy Seckler, "Interview with Seymour Lipton," April 28, 1964, transcript, Archives of American Art, Smithsonian Institution, Washington, D.C., p. 9.

2. Ibid., p. 4.

3. This aspect of postwar American sculpture is discussed by Lisa Phillips in *The Third Dimension: Sculpture of the New York School,* exh. cat. (New York: Whitney Museum of American Art, 1984), pp. 31–39.

4. Clement Greenberg, "David Smith," *Art and Culture* (Boston: Beacon Press, 1961), pp. 203-04. This essay first appeared in *Art in America,* 44 (Winter 1956-57), pp. 30-33, 66, as part of a special issue on contemporary sculpture.

WORKS IN THE EXHIBITION

Dimensions are in inches; height precedes width precedes depth.
All works are on paper.

LOUISE BOURGEOIS

Unless otherwise noted, all works are lent by the artist; courtesy Robert Miller Gallery, New York.

1. *Untitled*, 1943
 Ink, 9 x 12
 Fig. 38; illus. p. 62

2. *Untitled*, 1943
 Ink, 9 x 11½
 Signed (at lower right): LB

3. *Untitled*, 1946
 Ink, 14¼ x 5¾
 Signed (at lower right):
 Louise/Bourgeois
 Fig. 41; illus. p. 64

4. *Untitled*, 1946
 Pencil, 11 x 8½
 Signed (at lower right): LB

5. *Femme Maison*, 1947
 Ink and gouache, 12¼ x 9¼
 Signed (at lower right): LB
 Collection M. Anthony Fisher
 Fig. 40; illus. p. 60

6. *Untitled*, 1947
 Ink and charcoal, 11 x 8¾
 Signed and dated (at lower right):
 Bourgeois 47
 PL. VI; illus. p. 87

7. *Untitled*, 1947
 Ink and charcoal, 11 x 7½
 Signed (at lower right):
 Louise Bourgeois

8. *Untitled*, 1947
 Ink, 11¼ x 7³⁄₁₆
 Signed (at lower right):
 Louise Bourgeois

9. *Untitled*, 1948
 Ink and pencil, 10⅞ x 8¼
 Signed (at lower right): L.B.

10. *Untitled*, 1948
 Ink, 11 x 8½
 Signed and dated (at lower left):
 Bourgeois/48
 Fig. 39; illus. p. 63

11. *Untitled*, 1949
 Ink, 8¾ x 13½
 Signed (at lower right):
 L. Bourgeois
 Fig. 43; illus. p. 66

12. *Untitled*, 1949
 Ink, 14 x 11

13. *Untitled*, 1949
 Ink, 11¾ x 9¾
 Signed (at lower center): LB

14. *Untitled*, 1949
 Ink, 11 x 8½
 Signed (at lower right): Bourgeois

15. *Untitled*, 1949
 Ink, 11 x 8½
 Signed (at lower right):
 Louise Bourgeois
 Collection John Eric Cheim

16. *Untitled*, 1950
 Ink, 14 x 11
 Signed twice (at lower right): LB
 Collection John Eric Cheim
 Fig. 44; illus. p. 67

17. *Untitled*, 1950
 Ink, 8¹⁄₁₆ x 5⁵⁄₁₆

18. *Death of the Dog*, 1950
 Ink, 19½ x 12¾
 Signed and inscribed (at lower
 right): Louise Bourgeois/Death of
 the Dog
 Fig. 42; illus. p. 65

19. *Untitled*, 1950
 Ink, 12¾ x 6¾
 signed (at lower right):
 Louise/Bourgeois

20. *Untitled*, 1950
 Ink, 11 x 8½

21. *Untitled*, 1950
 Ink, 19 x 12⅜
 Signed and dated (at lower right):
 L. Bourgeois 50

22. *Untitled*, 1953
 Ink, 8½ x 11
 Signed (at lower right): LB

DOROTHY DEHNER

Unless otherwise noted, all works are lent by the artist; courtesy Richard L. Eagan Fine Arts, New York.

23. *The Gift Tree*, 1948
 Ink and wash, 17½ x 13
 Signed and dated (at lower right):
 Dorothy Dehner '48
 Fig. 12; illus. p. 26

24. *Leewenhoek's Dream #3*, 1948
 Ink and wash, 13 x 17¼
 Signed and dated (at lower right):
 Dorothy Dehner '48;
 inscribed (at lower left):
 Leewenhoek's Dream #3
 Fig. 11; illus. p. 28

25. *Measure of Time*, 1948
 Ink and gouache, 17½ x 13¼
 Signed and dated (upper right):
 Dehner '48

26. *Personage (Male/Female)*,
 about 1948
 Gouache, 17½ x 13
 Signed (lower right): Dehner;
 inscribed (on the back): Despite
 the many Sins and Small Diversions
 Fig. 13; illus. p. 29

27. *Untitled (Bolton Landing)*, 1949
 Ink and wash, 18¼ x 22⅞
 Signed and dated (at lower right):
 Dorothy Dehner '49

28. *Untitled*, 1949
 Ink, 15¾ x 20⅜
 Signed and dated (at lower left):
 Dorothy Dehner '49
 Private Collection, Southold, N.Y.
 Fig. 16; illus. p. 32

29. *In the Garden*, 1949
 Ink and wash, 18½ x 22½
 Signed and dated (at lower left):
 Dorothy Dehner '49
 Private Collection, New York, N.Y.

30. *Untitled*, 1949
 Ink, 18 x 23
 Signed and dated (at lower right):
 Dorothy Dehner '49

31. *Untitled*, 1950
 Colored ink and gouache,
 17¾ x 13
 Signed and dated (at lower right):
 Dorothy Dehner '50

32. *Animal*, 1950
 Ink and wash, 18¼ x 23
 Signed and dated (at lower right):
 Dorothy Dehner '50

33. *Homage to Squares*, 1950
 Watercolor, 8¾ x 9
 Signed and dated (at lower right):
 Dorothy/Dehner '50
 Private collection, Cos Cob,
 Connecticut

34. *The Way #10*, 1951
Ink and wash, 18 x 23
Signed and dated (at lower right):
Dorothy Dehner '51;
inscribed (on the back):
#58 The Way #10.
Fig. 15; illus. p. 31

35. *The Conversation*, 1953
Ink and wash, 25 x 20
Signed and dated (at lower left):
Dorothy Dehner '53;
inscribed (on the back): Dorothy
Dehner "Conversation"/Saw Mill
Farm/New City, N.Y./$200

36. *Untitled*, 1955
Ink, 20½ x 15½
Signed and dated (at lower right):
D.D. '55

37. *Untitled*, 1955
Ink, 20½ x 15½
Signed (at lower right): D. Dehner

38. *Wraiths from a Small Village*,
1956
Ink and wash, 24¾ x 37¾
Signed and dated (at lower left):
Dorothy Dehner '56
Private collection,
New York, N.Y.

39. *Untitled*, 1957
Ink and wash, 25 x 19
Signed and dated (at lower left):
Dorothy Dehner '57
Private collection, New York, N.Y.
PL.II; illus. p. 83

40. *Untitled*, 1959
Ink, 13½ x 10¾
Signed and dated (at lower right):
Dehner '59
Fig. 14; illus. p. 30

41. *Untitled*, 1959
Ink, 13¾ x 10¾
Signed and dated (at lower right):
Dehner '59

HERBERT FERBER

Unless otherwise noted, all works are
collection Mrs. Edith Ferber.

42. *Untitled*, 1944
Ink, pencil, colored pencil, and
gouache, 10¹⁵⁄₁₆ x 14¾
Signed (at lower right): Ferber 44

43. *Untitled* (Study for "Head in
Hand"), 1945
Gouache and pencil, 13 x 16⅞
Signed and dated (at lower right):
Ferber/Aug. 45
Private collection
Fig. 17; illus. p. 36

44. *Untitled*, 1946
Ink and colored washes, 14⅞ x 11
Signed (at lower left):
Ferber Feb. 46

45. *Untitled*, 1947
Ink, drybrush, pencil, and sepia,
8¹⁵⁄₁₆ x 11⅝
Signed (at lower right):
Ferber-8-47
Fig. 19; illus. p. 37

46. *Untitled*, 1947
Ink, colored pencil, and gouache,
11⅜ x 9
Signed (at lower right):
Ferber 3-47

47. *Untitled*, 1947
Ink, colored pencil, and gouache,
11⅝ x 9
Signed (at lower right): Ferber 47

48. *Untitled*, 1947
Ink, gouache, dry brush,
11⅝ x 8¾
Signed (at lower right):
Ferber-5-47

49. *Untitled*, (Study for "Apocalyptic
Rider"), 1947
Ink and gouache, 14 x 10
Signed (at lower right):
Ferber 8-47
PL. III; illus. p. 84

50. *Portrait of a Sensualist*, 1947
Ink, gouache and washes,
15¾ x 10½
Signed (at lower right):
Ferber 3-47;
inscribed (at lower right):
Portrait of a Sensualist

51. *Untitled*, 1949
Ink, 9 x 12½
Signed (at lower left): Ferber 49

52. *Untitled*, 1949
Ink, 12¹⁄₁₆ x 12¹⁄₁₆
Signed (at lower right):
Ferber 2-49
Fig. 18; illus. p. 34

53. *Untitled*, 1949
Ink and wash, 16¾ x 12½
Signed (at lower right):
Ferber/8-49

54. *Untitled*, 1949
Ink and colored washes,
12½ x 9¹⁵⁄₁₆
Signed (at lower right): Ferber 49
Related to *Labors of Hercules*
(1948); probably dated
subsequently.

55. *Untitled*, 1950
Ink and wash, 10 x 12
Signed (at lower left): Ferber 7-50

56. *Untitled*, 1950
Sepia ink, 18¾ x 12
Signed (at lower left): Ferber 50

57. *Untitled* (Study for "Roofed
Sculpture"), 1953
Ink, pencil, gouache, and wash,
9¾ x 12½
Signed (at lower right): Ferber 53

58. *Untitled*, (Study for "Roofed
Sculpture"), 1954
Ink, gouache, and wash,
12¹⁵⁄₁₆ x 19⅞
Signed (at lower right): Ferber 54
Fig. 20; illus. p. 38

59. *Untitled*, 1958
Oil, 13¹³⁄₁₆ x 11
Signed (at lower right): Ferber 58

60. *Untitled*, 1958
Oil, 20¹⁄₁₆ x 12¹⁵⁄₁₆
Signed (at lower right): Ferber 58
Related to *Heraldic* (1957)

61. *Untitled*, 1958
Oil, 22⅝ x 15½
Signed (at lower right): Ferber/58
Fig. 21; illus. p. 39

62. *Untitled*, 1958
Oil and ink, 22⅛ x 14¹⁵⁄₁₆
Signed (lower center): Ferber/58

63. *Untitled*, 1958
Oil and ink, 17⅞ x 12
Signed and dated (at lower right):
Ferber 58
Fig. 22; illus. p. 40

SEYMOUR LIPTON

Unless otherwise noted, all works are
collection James and Barbara Palmer.

64. *Untitled*, about 1945
Ink, 11¾ x 8¾
Signed (at right center): Lipton
Fig. 45; illus. p. 70

65. *Untitled*, about 1945
Ink, 11 x 8½

66. *Study for "Argosy,"* about 1946
Ink, 8¾ x 11¾

67. *Untitled* (Study for "Imprisoned
Figure"), about 1948
Pencil, 11 x 8½
Fig. 47; illus. p. 72

68. *Untitled* (Study for "Imprisoned
Figure"), about 1948
Ink, 11 x 8½
Fig. 48; illus. p. 72

69. *Untitled*, about 1949
Conté crayon, 11 x 8½

70. *Study for "Sorcerer,"* about 1950
Ink and pencil, 8½ x 11

71. *Study for "Sorcerer,"* about 1950
Pencil, 8½ x 11

72. *Study for "Spring Ceremonial,"*
about 1951
Ink, 11 x 8½

73. *Study for "Spring Ceremonial,"*
about 1951
Ink, 8½ x 11
Dated (at lower right): 3/20/50

74. *Study for "The Cloak,"* 1951
Ink, 11 x 8½
Signed and dated (at lower right):
Lipton 51
Fig. 51; illus. p. 68

75. *Untitled* (Study for
"Thunderbird"), 1951
Ink, 8½ x 11
Signed and dated (at lower right):
Lipton 51

76. *Study for "Earth Forge II,"* about
1953–54
Conté crayon, 8½ x 11
Fig. 50; illus. p. 74

77. *Study for "Germinal II,"* 1953
Pencil, 11 x 8½
Signed and dated (at lower right):
Lipton 53
Fig. 49; illus. p. 73

78. *Study for "Sanctuary,"* 1951–53
Pencil, 11 x 8½
Signed and dated (at lower right):
Lipton 51;
(at upper right): 1/3/53

79. *Study for "Sanctuary,"* 1953
Conté crayon, 11 x 8½
Signed and dated (at lower left):
Lipton 53

80. *Study for "Phoenix,"* 1956
Conté crayon, 11 x 8½
Signed and dated (at lower right):
Lipton 56

81. *Study for "Hero,"* about 1957
Conté crayon, 11 x 8½

82. *Study for "Hero,"* 1957
Conté crayon, 11 x 8½
Signed and dated (at lower right):
Lipton 57
PL. VII; illus. p. 88

83. *Studies for "Sorcerer,"* 1958
Pen and ink, 11 x 8½
Signed and dated (at lower right):
Lipton 58

84. *Study for "Seafarer,"* 1959
Conté crayon, 11 x 8½
Signed and dated (at lower left):
Lipton 59

85. *Study for "Prophet,"* 1959
Conté crayon, 11 x 8½
Signed and dated (at lower left):
Lipton 59
Fig. 52; illus. p. 74

ISAMU NOGUCHI

All works are collection The Isamu
Noguchi Foundation, Inc.

86. *Study for Sculpture,* about
1942–48
Pencil, 11 x 8½

87. *Studies for "Monument to Heroes"
and "Bell Tower for Hiroshima,"*
about 1943–50
Pencil, 10⅝ x 14⅞
Fig. 31; illus. p. 54

88. *Worksheet for Sculpture,* 1945
Pencil, graph paper on black
paper, 17 x 22
Signed and dated (at lower right):
Isamu Noguchi 1945
PL.V; illus. p. 86

89. *Worksheet for Sculpture,* about
1945–47
Pencil, graph paper on black
paper, 17 x 22

90. *Worksheet for Sculpture,* about
1945–47
Pencil, graph paper on black
paper, 17 x 22
Inscribed (at lower left): Emily
Weather/PL5 6271
Fig. 35; illus. p. 57

91. *Untitled,* 1945
Pencil, 11 x 8⅝
Signed and dated (at lower right):
Isamu Noguchi/'45

92. *Nine Studies for Sculpture,* 1945
Pencil, 10¹⁵⁄₁₆ x 13⅞
Signed and dated (at upper right):
Isamu Noguchi '45

93. *Ten Studies for Sculpture
(including "Avatar"),* 1946
Pencil, 13⅞ x 10⅞
Signed and dated (at upper left):
Isamu Noguchi/1946
Fig. 34; illus. p. 56

94. *Twelve Studies for Sculpture
(including "Little Slate"),* 1946
Pencil, 13⅞ x 10¾
Signed and dated (at upper left):
Isamu Noguchi 1946

95. *Five Studies for Sculpture,* 1946
Pencil, 10⅞ x 13¹³⁄₁₆
Signed and dated (at lower left):
Isamu Noguchi 1946

96. *Study for Sculpture ("The Gunas"),*
about 1946
Pencil, 11¹⁵⁄₁₆ x 9

97. *Ten Studies for Sculpture
(including "Cronos"),* 1947
Pencil, 13¹³⁄₁₆ x 10⅞
Signed and dated (at upper left):
Isamu Noguchi/'47

98. *Fifteen Studies for Sculpture,* 1947
Pencil, 10⅞ x 13¹³⁄₁₆
Signed and dated (at lower right):
Isamu Noguchi 1947
Fig. 33; illus. p. 55

99. *Study for Sculpture,* 1947
Pencil, 11¹⁵⁄₁₆ x 9
Signed and dated (at lower right):
Isamu Noguchi/1947
Fig. 32; illus. p. 52

100. *Thirteen Studies for
Sculpture,* 1947
Pencil, 10⅞ x 13¹³⁄₁₆
Signed and dated (at lower
right): Isamu Noguchi/1947

101. *Study for Sculpture,* 1947
Pencil, 13⅞ x 10¹⁵⁄₁₆
Signed and dated (at lower right):
Isamu Noguchi/1947

102. *Beginning the Seasons,* 1947
Pencil, 13¹³⁄₁₆ x 10¹⁵⁄₁₆
Signed and dated (at lower right):
Isamu Noguchi 1947;
inscribed (at lower left):
Beginning "The Season"

103. *Twenty–five Studies for Sculpture,*
1952
Pencil, 14¼ x 10¾
Signed, dated, and inscribed (at
upper right): Isamu
Noguchi/Japan/1952

104. *Two Studies for Sculpture
(including "The Cry"),* 1957
Pencil, 10⅝ x 14½
Signed and dated (at lower right):
Noguchi '57
Fig. 36; illus. p. 58

105. *Nineteen Studies for Sculpture and
a Garden,* 1957
Pencil, 12⅝ x 17⁵⁄₁₆
Signed and dated (at upper left):
Isamu Noguchi 1957

106. *Twenty–five Studies for Sculpture
(including "Mortality"),*
about 1955–59
Pencil and ink, 14 x 16¾
Fig. 37; illus. p. 58

107. *Seventeen Studies for Sculpture,*
1959
Pencil, 14 x 16¾
Signed and dated (at lower right):
Isamu Noguchi 59

THEODORE ROSZAK

Unless otherwise noted, all works lent courtesy Theodore Roszak Estate.

108. *Study for Sculpture*, about 1945
Gouache, 23⅞ x 17⅞

109. *Study for Sculpture
(Sea Quarry)*, about 1945
Gouache and ink, 14 x 9¹⁵⁄₁₆
Fig. 23; illus. p. 42

110. *Study for "Spectre of Kitty Hawk,"*
1945
Ink and wash, 26½ x 34¼
Signed and dated (at lower left):
T. Roszak—1945 N.Y.C.
Fig. 28; illus. p. 48

111. *Study for "Raven,"* about 1947
Ink and wash, 15⅛ x 21⅝

112. *Study for "Thorn Blossom,"*
about 1947
Gouache, 14⅞ x 10½
Signed (at lower right):
T. J. Roszak
Fig. 24; illus. p. 44

113. *Studies for "Skylark,"* 1950–51
Ink and wash, 31⅛ x 22⅞

114. *Studies for "Skylark,"* 1950–51
Ink and wash, 29¾ x 22⅞
Fig. 30; illus. p. 50

115. *Study for "The Furies,"*
about 1950
Ink and wash, 21⅞ x 29⅞
Signed (at bottom center): T.J.
Roszak N.Y.C./The Furies;
inscribed (on the back): Study
for/(The Furies)/Theodore J.
Roszak

116. *Nova*, 1950
Ink and wash, 40¾ x 28½
Signed (along lower left edge):
Theodore Roszak 1950 "Nova";
inscribed (on the back): Nova/
Theodore Roszak/Nova
PL.IV; illus. p. 85

117. *Study for "Monument to an
Unknown Political Prisoner,"*
about 1952
Ink and wash, 26¼ x 33¼
Signed (at lower right):
Theodore Roszak; inscribed
(on the back): Study for
Monument/Theodore Roszak
Fig. 29; illus. p. 49

118. *Studies for "Monument to an
Unknown Political Prisoner"
and "Reynold's Memorial,"* about
1952
Ink and wash, 12½ x 10

119. *Study for "Fledgling,"*
about 1953
Ink and wash, 13¾ x 10⅞

120. *Study for "Fledgling,"*
about 1953
Ink and wash, 30 x 22¼
Signed and dated (at lower right):
Theodore Roszak '53
Private collection

121. *Studies for "Hound of Heaven,"*
about 1953–54
Ink, 10¾ x 13⅞

122. *Studies for "Sea Sentinel,"* 1954
Ink and wash, 10¾ x 14
Signed (at bottom center):
T. Roszak; inscribed
(on the back): Group of studies
for/Sea Sentinel/1954/No. 21

123. *Study for "Thistle in the Dream,"*
about 1955–56
Ink and wash, 21¾ x 15

DAVID SMITH

Unless otherwise noted, all works are
collection Candida and Rebecca Smith.

124. *Untitled (Studies for "Perfidious
Albion")*, 1944
Ink, pencil, and wash, 19½ x 25
Signed and dated (at upper right):
ΔΣ 1944
Fig. 1; illus. p. 18

125. *Study for "Personage from
Stove City,"* 1946
Oil, 20 x 26¼
Signed and dated (at upper right):
David Smith 1946;
inscribed overall with various
instructions for sculpture
Fig. 2; illus. p. 19

126. *Untitled*, 1951
Black egg ink, blue ink, pink,
aqua and orange
tempera, oil, 15 3/4 x 20¼
Signed and dated (at lower right);
ΔΣ 7-51; (on the back): Nude

127. *Untitled*, 1951
Black egg ink, gray and white
tempera, 25¾ x 19¾
Signed and dated (at upper right):
ΔΣ 11-4-51
PL. I; illus. p. 82

128. *Sculptural #1*, 1951
Black, yellow, and green egg ink,
18¼ x 22¾
Signed and dated (at lower right):
ΔΣ 1951; inscribed (on the back):
Sculpture #1 C-196 #1

129. *Study for "The Hero,"* 1951
Ink and egg ink, 18⅛ x 22¾
Signed, dated, and inscribed (at
lower right): ΔΣ 6/19/51/VERTICLE
Const The Hero/Approx human
female with base
Collection Terese and
Alvin Lane
(Exhibited only at The Parrish Art
Museum)
Fig. 8; illus. p. 21

130. *Untitled*, 1952
Black egg ink, blue and yellow
ink, 18 x 23⅜
Signed and dated (at lower left);
ΔΣ 4/14/52

131. *Untitled*, 1952
Black egg ink, 42½ x 29¾
Signed and dated (at lower right):
ΔΣ 12/12/52
Fig. 3; illus. p. 16

132. *Untitled*, 1953
Black and blue egg ink,
15½ x 20¼
Signed and dated (at upper right):
ΔΣ 18/5/3/53
Fig. 6; illus. p. 21

133. *Study for "Tanktotems,"* 1953
Black egg ink, pencil, and
tempera, 15¾ x 12¼
Signed and dated (at lower left):
ΔΣ Nov 53
Fig. 5; illus. p. 20

134. *Untitled*, 1955
Black ink, 17 x 21
Signed and dated (at bottom
center): ΔΣ 2/10/55

135. *Untitled*, 1958
Black egg ink, 29¾ x 42¼
Signed and dated (at lower right):
David Smith 1-9-58

136. *Untitled*, 1958
Black egg ink, 19½ x 24½
Signed and dated (at lower left):
David Smith B 5/58 19
Fig. 4; illus. p. 20

137. *Untitled*, 1959
Black egg ink, 17½ x 26
Signed and dated (at lower left):
David Smith/2-12-59
Fig. 10; illus. p. 25

138. *Untitled*, 1959
Spray paint, 17½ x 11½

139. *Untitled*, 1959
Spray paint with white in paint
and pencil, 17½ x 11½
Dated (at lower right): 5/59

SCULPTURE

HERBERT FERBER

All works are collection Edith Ferber; courtesy Knoedler & Company, New York

1. *Three-legged Woman II*, 1945
 Bronze, 23¼ x 14½ x 15½

2. *Metamorphosis II*, 1946
 Bronze, 6 x 12 x 6

3. *Conflict III*, 1948
 Bronze, 4½ x 10½ x 8

SEYMOUR LIPTON

4. *Imprisoned Figure* (maquette), 1948
 Lead, 9 high
 Collection James and Barbara Palmer

5. *Sorcerer*, about 1950
 Steel brazed with nickel-silver, 24 high
 Private collection; courtesy Babcock Galleries, New York

6. *Prophet* (maquette), 1956
 Sheet iron, 14 high
 Private collection; courtesy Babcock Galleries, New York

7. *Phoenix, 1957*
 Monel metal brazed with nickel-silver, 12 high
 Collection James and Barbara Palmer

THEODORE ROSZAK

Unless otherwise noted, all works courtesy Theodore Roszak Estate.

8. *Sea Quarry*, 1947
 Steel brazed with nickel-silver, 9 x 11¾ x 8

9. *Study for "Hound of Heaven,"* 1953–54
 Steel, 12⅞ x 3¾ x 5

10. *Fledgling*, 1953
 Steel brazed with copper and brass, 29 x 14½ x 11½
 Private collection

11. *Sea Sentinel*, 1956
 Steel brazed with nickel-silver, 27¼ x 12½ x 16⅞

PLATES

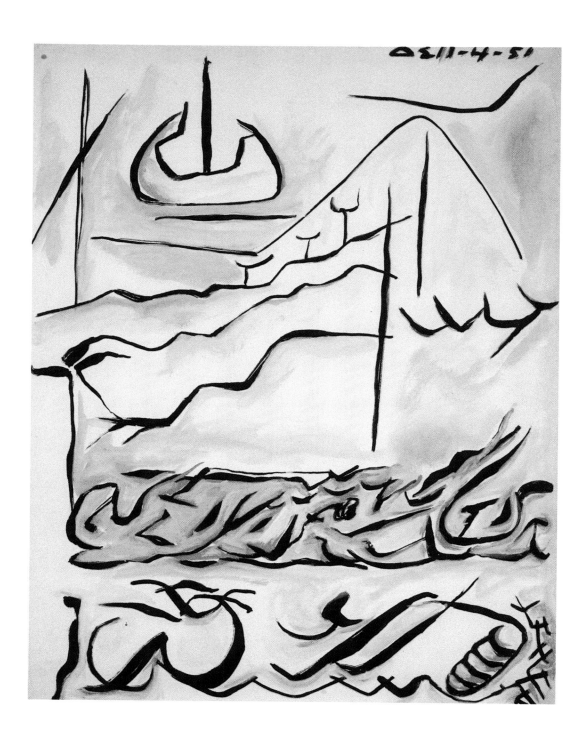

I. David Smith, *Untitled*, 1951. CAT. 127

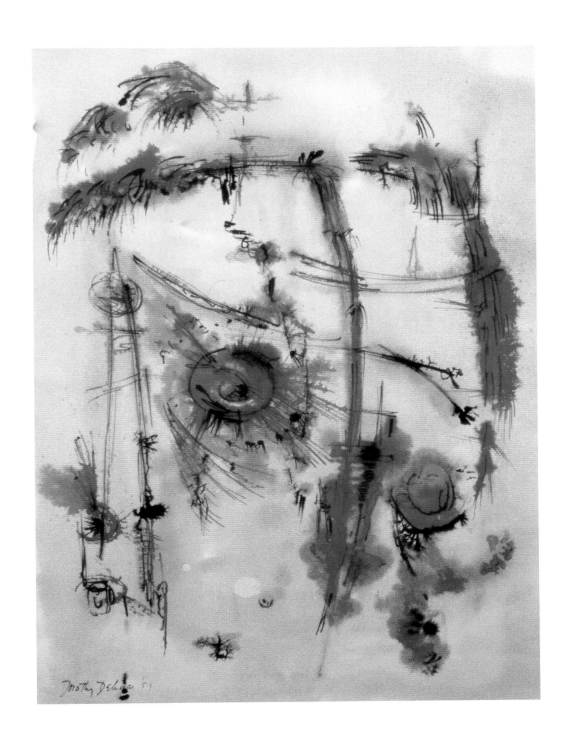

II. Dorothy Dehner, *Untitled*, 1957. CAT. 39

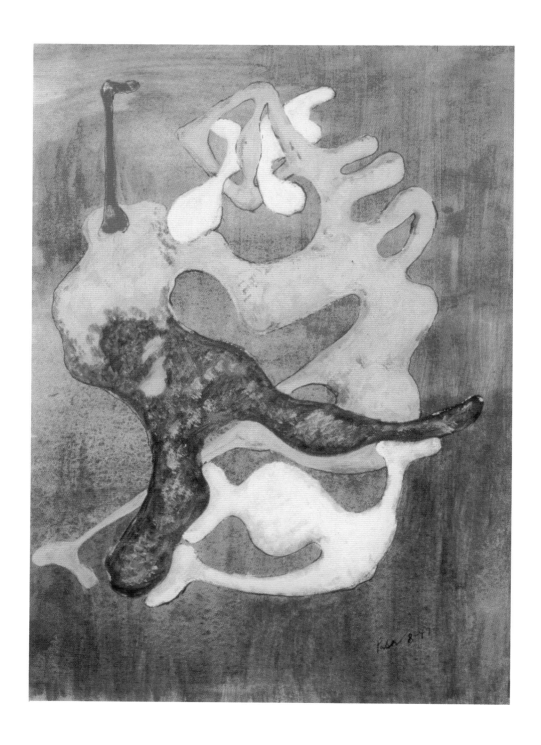

III. Herbert Ferber, *Untitled*, (Study for "Apocalyptic Rider"), 1947. CAT. 49

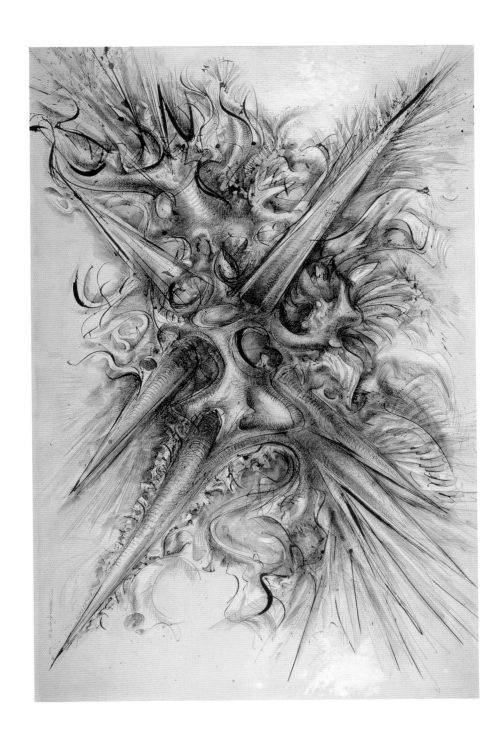

IV. Theodore Roszak, *Nova*, 1950. CAT. 116

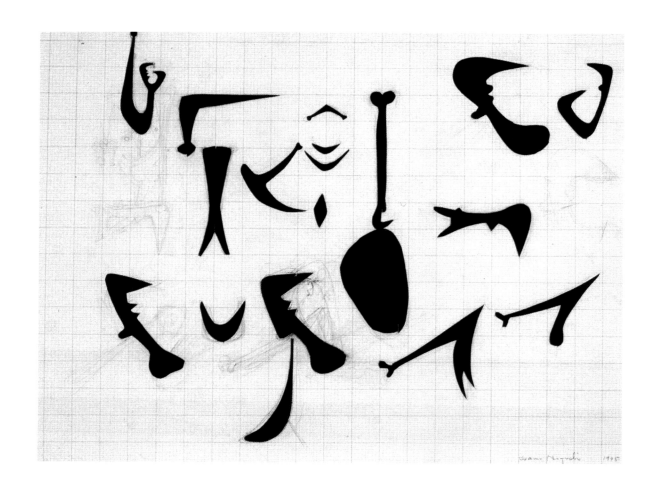

V. Isamu Noguchi, *Worksheet for Sculpture*, 1945. CAT. 88

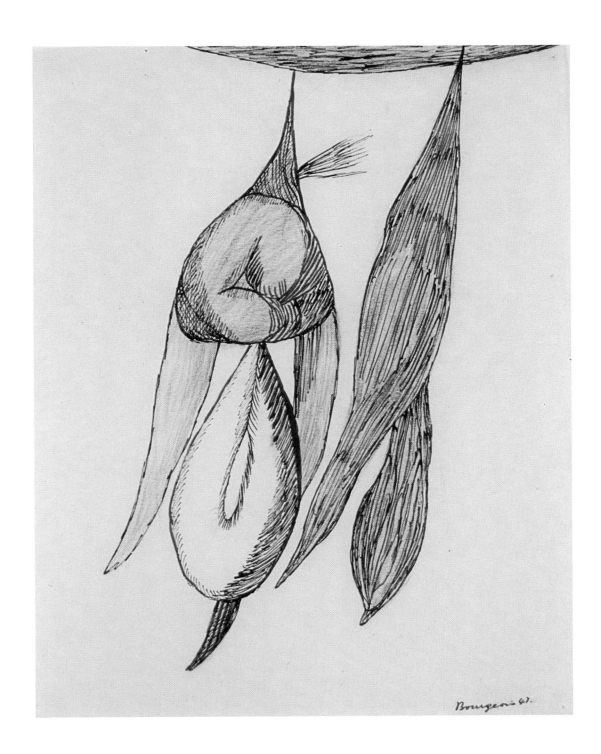

VI. Louise Bourgeois, *Untitled*, 1947. CAT. 6

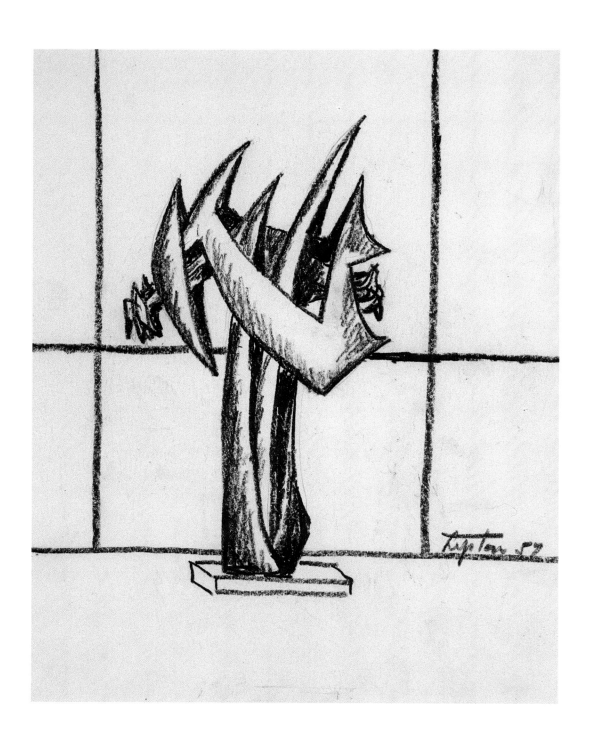

VII. Seymour Lipton, *Study for "Hero,"* 1957. CAT. 82

CHRONOLOGIES

1911

Born in Paris on December 25 to Josephine Fauriaux and Louis Bourgeois. The middle child, she has sister, Henriette, six years older; brother Pierre born 15 months later. Lives first at 147, boulevard Saint Germain, and later at 172, boulevard Saint Germain, in apartment above parents' gallery, which deals primarily in tapestries.

1912–1919

In 1912, family acquires house in Choisy-le-Roi, outside Paris, where they live until 1918. During war years, with her mother, sister, and brother, spends time in Aubusson with family relatives. Also makes trips with mother to visit father at various military encampments. Father wounded in 1915, brought to hospital in Chartres to recuperate.

1919–1932

In 1919, family buys property in Antony, outside Paris, on banks of Bièvre River, and sets up workshop for restoration of tapestries, taking advantage of special chemical makeup of river for dyeing and other restoration processes. Family also maintains Paris property housing apartment and gallery. Attends Lycée Fénelon, in Paris, earning baccalauréat in 1932. From her teen years, helps out in tapestry workshop with drawing. From 1922 to 1932 takes yearly winter trips to South of France, where mother takes cures. Takes summer vacation trips to England to practice English, which her father, experienced in business, regards as important.

1932–1938

Mother dies in 1932.
Enrolls at Sorbonne to study mathematics, eventually leaving to study art. Prepares for entry into Ecole des Beaux-Arts. After acceptance and brief study there, leaves for less academic, freer atmosphere of instruction in ateliers. Studies at Académie Ranson, Académie Julian, and Académie de la Grande-Chaumière (where she works as studio assistant). Also studies art history at Ecole du Louvre and works as docent at Louvre, using knowledge of English.

1938

September, marries an American, Robert Goldwater, and in October, moves to New York, living first in apartment at Park Avenue and East 38th Street. Has three sons, Michel, Jean-Louis, and Alain, and a marriage of more than 30 years. Enrolls at Art Students League. Studies painting there for two years with Vaclav Vytlacil.

1939

Moves to East 41st Street, remaining there for two years. Exhibits for first time in U.S., in print exhibition at The Brooklyn Museum. During early years exhibits prints there and at Philadelphia Print Club, Library of Congress, and Pennsylvania Academy of the Fine Arts. Soon after arrival in U.S., meets and establishes close friendship with Gertrude and Balcomb Greene, active members of American Abstract Artists group.

1941

Moves to apartment, known as Stuyvesant's Folly, on East 18th Street, where she lives until 1958. Will experiment with large-scale wood sculpture on roof of apartment house. Family purchases country home in Easton, Connecticut, where she and children spend long stretches of time during war years.

1942–1945

Takes part in art-world activities involving war effort, including exhibitions organized under auspices of the Artists for Victory. Receives Honorary Award, along with Alexander Calder and André Masson, for tapestry entered in The Museum of Modern Art's *The Arts in Therapy* exhibition. June 1945, organizes *Documents France 1940–1944: Art-Literature-Press of the French Underground*, at Norlyst Gallery. June 1945, first solo exhibition, *Paintings by Louise Bourgeois*, at Bertha Schaefer Gallery. Exhibits 12 paintings. Exhibits for first time in Whitney Museum of American Art Annual of Painting. Begins working at Atelier 17, where she will make prints through latter part of decade. Becomes friendly there with artists such as Nemecio Antunez, Le Corbusier, Joan Miró, Yves Tanguy, and Ruthven Todd.

1947

September, second solo exhibition, at Norlyst Gallery. Exhibits 17 paintings. Publishes *He Disappeared into Complete Silence*, suite of engravings and parables made at Atelier 17.

1949

October, makes debut as sculptor at Peridot Gallery, at invitation of Louis Pollock, gallery director, and his friend and collaborator, Arthur Drexler, who also helps install exhibition. Shows 17 pieces.

1950–1951

April 1950, takes part in three-day session for advanced artists at Studio 35 (35 East Eighth Street). May 1950, joins group of artists, who become known as "Irascibles," in protest against planned American painting exhibition at The Metropolitan Museum of Art. October 1950, second show of sculpture at Peridot Gallery. Exhibits 15 pieces. The Museum of Modern Art acquires *Sleeping Figure* in 1951. Father dies. In 1951, becomes U.S. citizen. Interrogated extensively at naturalization hearings about art-world associations, perhaps thought to be Left Wing by Cold-War era immigration officials.

1952

January 19, performance of Erick Hawkins's dance, *The Bridegroom of the Moon*, for which Bourgeois has designed set. Takes place at Hunter Playhouse, New York.

1953–1958

April 1953, third solo show at Peridot Gallery. Exhibits either two or three sculptures, and series of India ink drawings. Marks debut of organic multiformsculptures. Takes part in many group shows, at galleries such as Stable and Poindexter and with organizations such as American

Abstract Artists (of which she becomes a member in 1954) and Federation of Modern Painters and Sculptors. Exhibits in Annuals of Whitney Museum of American Art from 1953 through 1957. Whitney Museum acquires *One and Others* in 1956. In 1958, moves from "Stuyvesant's Folly," to West 22nd Street, where she will remain for four years.

1959
Participates in Festival of Contemporary Arts at The Andrew Dickson White Art Museum, Cornell University, Ithaca, New York. Exhibits 11 wood figural sculptures. Alan Solomon, director of museum, is curator of exhibition.

1960–1965
Continues to take part in various group exhibitions at galleries such as Frumkin, Stable, Tanager, Great Jones, A. M. Sachs, and Noah Goldowsky. Exhibits regularly with Sculptors Guild. Begins to teach regularly, first adults and children at Great Neck, Long Island, N.Y., public schools, in 1960, and then at college level at Brooklyn College, in 1963 and 1968, and at Pratt Institute, Brooklyn, in 1964 and from 1965 to 1967. In 1962, moves from West 22nd Street to West 20th Street. January 1964, solo show at Stable Gallery. Exhibits approximately 12 plaster pieces. In concurrent solo show at Rose Fried Gallery, exhibits drawings and watercolors. In 1965, participates in Waldorf Panels for Sculpture; published in *It Is* magazine late that year.

1966
September, takes part in group exhibition *Eccentric Abstraction*, organized by Lucy R. Lippard at Fischbach Gallery. Becomes actively involved in political and feminist events in latter part of decade.

1967
Wayne Andersen discusses Bourgeois's place in the artistic developments of the fifties in "American Sculpture: The Situation in the Fifties," *Artforum* (Summer). First trip to marble works at Pietrasanta, Italy. Travels there regularly until 1972, usually in summer but sometimes twice in one year. Produces at least 13 major marble pieces there, as well as many smaller pieces. Also works in bronze foundries there.

1969
William Rubin discusses Bourgeois's place in contemporary painting and sculpture in *Art International* (April).

1970
Continues to take part in demonstrations, benefits, panels, and exhibitions connected with feminism in the arts and does so throughout decade.

1971
J. Patrice Marandel writes in *Art International* (December) on Bourgeois's recent activities in Italy.

1973
Receives Artist's Grant from National Endowment for the Arts. Designs sets, costumes, and poster for Women's Interart Center production of Tennessee Williams's *This Property Is Condemned* and August Strindberg's *The Stronger*. January, shows environmental-scale marble floor piece *Number Seventy-two* (later known as *The No March*) at

Whitney Museum of American Art Biennial. Musée National d'Art Moderne, Paris, acquires *Cumul, I*. Transfers sculpture to Centre George Pompidou in 1976. Husband dies in March.

1974
December, solo show at 112 Greene Street Gallery. Exhibits several marbles; several bronzes; several plasters (and hydrocal); and the environmental work, *The Destruction of the Father*. Participates in Seminars with Artists and Critics program of Whitney Museum of American Art, returning for another seminar in 1976. Begins teaching at The School of Visual Arts, continuing to do so through 1977. Holds other teaching positions in seventies at Columbia University, Cooper Union, and Goddard College (Plainfield, Vermont); has Visiting Artist assignments at Pratt Institute, Philadelphia College of Art, Woodstock Artists Association, Rutgers University (New Brunswick, New Jersey), New York Studio School, and Yale University. Acts as juror for New York State's *CAPS* awards, and does so again in 1975. Also serves on juries for Massachusetts State Council Awards, 1976; Brandeis University Creative Arts Awards, 1978; and Yaddo, throughout seventies and into eighties.

1975
Lucy Lippard writes on Bourgeois in *Artforum* (March). Interviewed on videotape by Lynn Blumenthal and Kate Horsfield for their Video Data Bank. Discusses family background and student years in France, as well as working methods and motivations for specific pieces. Takes part in tribute to former teacher, Vaclav Vytlacil, an exhibition of his work and that of some of his students, at Montclair Art Museum, Montclair, New Jersey. Other exhibitions in which her participation arises from past associations are the retrospective of Atelier 17, at Elvehjem Art Center, Madison, Wisconsin, in 1977, and Brooklyn College Art Department's faculty show, *Past and Present 1942–1977*, in 1977. Wayne Andersen represents her in book surveying *American Sculpture in Process: 1930/1970*.

1976
Susi Bloch focuses on work of late forties and early fifties for *Art Journal* (Summer) interview. Prominent place in Whitney Museum of American Art's Bicentennial exhibition, *200 Years of American Sculpture*.

1977
Participates in panel Women Artists of the '50s, along with Anne Arnold, Gretna Campbell, Marisol, Marcia Marcus, and Pat Passloff. Receives Honorary Doctor of Fine Arts degree from Yale University.

1978
Three solo exhibitions: at Hamilton Gallery of Contemporary Art and Xavier Fourcade, Inc., in September; and at University Art Gallery, Berkeley, California, in December. In response to commission from General Services Administration, makes outdoor public sculpture *Facets to the Sun* for Norris Cotton Federal Building in Manchester, New Hampshire. Detroit Institute of Arts acquires version of *The Blind Leading the Blind*. Storm King Art Center, Mountainville, N.Y., acquires *Number Seventy-two (The No March)*.

1979

September, solo show at Xavier Fourcade, Inc. Exhibits 33 wood figures and the recent *Partial Recall*. Eleanor Munro includes extensive essay in her book *Originals: American Women Artists*. Marsha Pels' interview appears in *Art International* (October).

1980

Paul Gardner writes "The Discreet Charm of Louise Bourgeois," for *Art News* (February). September, two solo shows, at Max Hutchinson Gallery and Xavier Fourcade, Inc. Posing in costume created for 1978 performance at Hamilton Gallery, is photographed for *Vogue* (October). Accompanies article by Carter Ratcliff tracing development and exploring psychological motivations. Purchases large loft space in Brooklyn for both work and storage. Australian National Gallery at Canberra acquires *C.O.Y.O.T.E.* Receives Award for Outstanding Achievement in the Visual Arts from Women's Caucus for Art at conference in New Orleans.

1981

May, solo show at The Renaissance Society, University of Chicago. Exhibits 31 pieces from the forties to the seventies, among them five early paintings; 15 early wood figures; three marbles, seven metal pieces; and suite of engravings, *He Disappeared into Complete Silence*. Chosen by critic Kay Larson for feature "Artists the Critics Are Watching" in *Art News* (May). Receives Honorary Doctor of Fine Arts degree from Bard College, Annandale-on-Hudson, New York. Elected Fellow of American Academy of Arts and Sciences. Spends over a month in Italy, first trip since 1972, working in Carrara rather than Pietrasanta. Produces more than 20 new marbles; produces largest marble to date, *Femme-Maison '81*.

1982–84

Given a retrospective, organized by Deborah Wye, at The Museum of Modern Art, New York (traveled). Has two solo exhibitions, one for sculpture and drawings, the other for sculpture, both at Robert Miller Gallery, New York.

1985

Has two solo exhibitions, one at Serpentine Gallery, London, England, the other at Maeght-Lelong, Paris.

1986

Has solo exhibition at Robert Miller Gallery, New York.

1987

Has solo exhibition of paintings from the 1940s at Robert Miller Gallery, New York and a retrospective at The Taft Museum, Cincinnati, Ohio (traveled).

1988

Has drawings retrospective at Robert Miller Gallery, New York, and Musem Overholand, Amsterdam, The Netherlands.

1989–91

Has solo exhibition of sculpture at Robert Miller Gallery, New York; shows works from the 1950s at Sperone-Westwater Gallery, New York; works from the 1960s at Dia Art Foundation, Bridgehampton, New York; recent sculpture at Art Gallery of York University, North York, Ontario, Canada; sculpture at American Academy of Arts and Letters, New York. Given a retrospective at Frankfurter Kunstverein (traveled). Has solo exhibition of recent sculpture at Robert Miller Gallery, New York.

1992

Has solo exhibition at Milwaukee Art Museum and a retrospective exhibition of prints at Barbara Krakow Galley, Boston, Massachusetts.

1993

Is the American representative at the Venice Biennale, Italy.

Reprinted, up to 1982, from Deborah Wye, Louise Bourgeois, *exh. cat. (New York: The Museum of Modern Art, 1982).*

DOROTHY DEHNER

1901
Born on December 23 in Cleveland, Ohio. Father was a pharmacist and a socialist; mother was a suffragette. Dorothy was the third child in the family. Her sister, Louise, was five years older, and her brother, John, was born two years before Dorothy, but died at nine months. At a young age, Dorothy began to draw and paint watercolors. She attended the Detroit Street School and the Watterson Public School until the seventh grade. Father died when she was eleven.

1915
Family moves to Pasadena, California. Mother dies the following year, and her sister Louise dies of tuberculosis. Dorothy attends John Muir Junior High School for eighth and ninth grades, and continues her interest in painting and drawing. Receives art instruction at Pasadena High School.

1918–1921
Studies and acts with Gilmor Brown at the Pasadena Playhouse. Drawing and painting continues, although no formal instruction. Studies modern dance and ballet privately.

1921–1922
Drama major at University of California, Los Angeles.

1922–1924
Moves to New York City to study at the American Academy of Dramatic Arts and to pursue a career in theater. Performs in The Little Theater's Off-Broadway productions with Walter Hartwig's Company.

1925
Travels alone to Europe, visiting Italy, Switzerland, and France. Sees the famous "l'Exposition Internationale des Arts Décoratifs et Industriels Modernes" in Paris, and returns with an enthusiasm for the "avant-garde." In September, enrolls at the Art Students League. Studies drawing with Kimon Nicolaides.

1926
In September, meets David Smith at a rooming house at 417 West 118 Street. Recommends that Smith enroll at the Art Students League. Dehner studies oil painting in Kenneth Hayes Miller's day class while taking Nicolaides' night class.

1927
On December 24, Dehner and Smith are married at City Hall in New York City. They move to 15 Abingdon Square. Both continue their instruction at the Art Students League.

1928
Spends summer in California. Dehner and Smith move to Myra Court in Flatbush, Brooklyn.

1929
Meets John Graham, and through Graham meets Stuart Davis, Arshile Gorky, and Milton Avery. Summer vacation in Bolton Landing, New York, as paying visitors to the Furlongs. Purchases farm with Smith at Bolton Landing in the Adirondack Mountains. From fall, 1929, to spring, 1931, studies with Jan Matulka at the Art Students League. Study with Matulka continues on Fourteenth Street.

1931–1932
September to following July, Dehner and Smith stay in the Virgin Islands. Dehner paints abstract still lifes incorporating sea shells.

1932
Fall, returns to 124 State Street, Brooklyn. Continues painting still lifes.

1935
Leaves for Europe with David Smith, visiting Paris, Brussels, and cities in Greece. Spends five months in Greece and Crete.

1936
Visits Malta, Leningrad, and Moscow before returning to England. In Russia sees collections of twentieth-century paintings, including Matisse, Picasso, and other French modernists. Returns to United States on July 4.

1936–1940
Lives in Brooklyn at 165 Congress Street; does still-life paintings, portraits, and drawings.

1940
Dehner and Smith settle permanently in Bolton Landing.

1941–1944
Paints egg tempera works depicting daily routine in "Life on the Farm" series. The idea for the miniature paintings came from *Les Très Riches Heures du Duc de Berry*, a French fifteenth-century book of hours.

1945
Spends five months in New York City, apart from Smith. Returns to Bolton Landing. Exhibits with Smith at Albany Art Institute, New York. Makes drawings of weeping women and "Dances of Death" (through 1947).

1946
Participates in the annual exhibition of the Audubon artists (work sent secretly to the competition). Awarded prize for drawing; show exhibited at the American Academy of Arts and Letters Gallery, New York City.

1948
Produces biomorphic drawings based on micro-organisms. Exhibition of drawings and gouaches at Skidmore College, Saratoga Springs, New York.

1949
Begins series of abstract geometric ink and watercolor drawings that are her favored means of expression until she begins sculpting in 1955.

1950

Exhibits for the first time at the Annual Exhibition, Whitney Museum of American Art. Finds various positions at Bolton Landing, including a teaching job during the summer months at the Franziska Boas School of Dance. Organizes exhibitions of local artists for the lobby of the Bolton Landing Summer Theater. In November, leaves Bolton Landing and separates from Smith.

1951

Takes courses at Skidmore College to obtain teaching credentials. Included in the Whitney Annual Exhibition.

1952

In January, receives a bachelor's degree from Skidmore College. Solo exhibition of watercolors at Rose Fried Gallery in New York. Begins teaching at Barnard School for Girls. Moves to Rockland County, New York. Divorce from Smith finalized. Begins making prints at Stanley William Hayter's Atelier 17. Meets Louise Nevelson and makes photographs of her work. Starts art program at the Indian Hill School of the Arts, Stockbridge, Massachusetts. Solo exhibition at the Albany Institute of History and Art.

1953

Participates in a group exhibition at the Metropolitan Museum of Art. The Museum of Modern Art acquires her watercolor, *From Japan*, 1951.

1955

Begins making sculpture in the lost-wax method. In May, participates in a three-artist show at the Willard Gallery (shows at Willard Gallery until 1976). Solo exhibition at the Art Institute of Chicago. Marries Ferdinand Mann and moves to 33 Fifth Avenue. Country residence is "Finney Farm" in Croton-on-Hudson, New York.

1957

First solo exhibition of sculpture held at the Willard Gallery. Obtains current studio space at 41 Union Square, her first work area separate from her living quarters. Exhibits in New Sculpture Group with Peter Agostini, Reuben Kadish, Philip Pavia, George Sugarman, and others. Invited to become a member of the Federation of Modern Painters and Sculptors, and the Sculptors Guild.

1959

Solo exhibition, Skidmore College. Participates in international exhibitions of prints (1959–1960s).

1960

Participates in *Aspects de la Sculpture Americaine*, Galerie Claude Bernard, Paris. First time showing sculpture at the Annual Exhibition, Whitney Museum of American Art.

1961

Solo exhibition, Columbia University, New York.

1965

Ten-year retrospective at The Jewish Museum, New York.

1970–1971

Receives Yaddo Foundation Fellowship. Visiting artist at the Tamarind Lithography Workshop.

1974

Ferninand Mann dies. Dehner begins working in wood.

1978

Solo exhibition, Parsons-Dreyfuss Gallery, New York.

1981

Produces a series of monumental sculptures in corten steel.

1982

Awarded Honorary Doctorate in Humane Letters, Skidmore College.

1983

Award from Women's Caucus for Art for outstanding achievement in the visual arts.

1984

Exhibition, *Dorothy Dehner and David Smith: Their Decades of Search and Fulfillment*, Jane Voorhees Zimmerli Art Museum, Rutgers, The State University of New Jersey, and Skidmore College Art Gallery.

1987

Solo exhibition, Associated American Artists, New York. Award of Distinction, National Sculpture Conference: Works by Women, University of Cincinnati.

1988

Included in exhibition, *Enduring Creativity*, Whitney Museum of American Art, Stamford, Connecticut. Solo exhibitions, Muhlenberg College, Allentown, Pennsylvania, and Twining Fine Art, New York.

1990

Solo exhibitions at The Phillips Collection, Washington, D.C., and Twining Fine Art, New York.

1991

Solo exhibition at Baruch College Art Gallery, New York.

1992

Solo exhibition, Perimeter Gallery, Chicago. Sculpture and drawings shown at Chicago Art Fair.

1993

Retrospective exhibition at the Katonah Museum of Art, New York. Works shown at Chicago Art Fair.

Reprinted from Joan M. Marter, Dorothy Dehner: Sixty Years of Art, *exh. cat. (New York: Katonah Museum of Art, 1993).*

1906
Born on April 30 in New York City, only child of Hattie
(née Lebowitz) and Louis Silvers, typesetter and trade school
printing teacher.

1923
Graduates from Morris High School in the Bronx. Member of
the soccer and rifle teams and school sports reporter for *New
York Herald Tribune*. Close friend of William Phillips, later
founder and co-editor of *Partisan Review*; through him later
meets Clement Greenberg and Harold Rosenberg. Enters
College of the City of New York.

1926
Majors in science and audits literature, philosophy, and art
history courses. Member of swimming team. By special
arrangement, leaves CCNY to enter Columbia University
Dental School. Meets Barnett Newman; William Steig, later
a *New Yorker* magazine cartoonist; and Jules Henry,
anthropologist who later introduces him to Margaret Mead.

1927
Awarded B.S. by Columbia University while enrolled in the
dental school. Enjoys anatomical drawing for dental classes
and begins drawing from nature and from sculpture at The
Metropolitan Museum of Art. During the next three years,
studies sculpture at night at tuition-free, instructorless
Beaux Arts Institute of Design, where Leo Lantelli and
Edward McCarten occasionally critique students' figure studies.

1929
Awarded $25 fourth prize, Beaux Arts Competition, for a
classical metope of Athena and Perseus with Medusa's head.
Studies etching on his own.

1930
Awarded D.D.S. from College of Oral and Dental Surgery,
Columbia University. Joins Columbia faculty as part-time
instructor and establishes part-time dental practice. Studies
for six months at National Academy of Design; expelled for
doing nonacademic figurative sculpture, but then is
reinstated. Exhibits landscape and figure etchings at
National Arts Club. Also exhibits at National Academy of
Design. Receives summer scholarship to work at Louis
Comfort Tiffany Foundation, Oyster Bay, Long Island. While
there, meets Ilya Bolotowsky and David McCosh, later head
of University of Oregon art department. In autumn, shares
studio with McCosh, who had been in Europe for a year, who
painted in the manner of Cézanne, and who later introduces
him to Theodore Roszak and other artists. Sees Guillaume
Collection of African sculpture, a strong influence. Works on
painting, etching, and sculpture, especially painting.

1931
Spends summer painting in Woodstock, New York, to which
he returns several times. Buys his first African sculpture.
Exhibits painting in group shows, Brooklyn Museum,
Pennsylvania Academy of the Fine Arts (Philadelphia)
Annual Exhibition of Painting and Sculpture (also 1942,
1943, 1945, 1946, 1954, 1958). Makes first wood carvings.

Shows photographs of work to William Zorach and asks to
study with him; Zorach advises him simply to purchase tools
and materials and work on his own.

1932
Marries Dr. Sonia Stirt, psychoanalyst. Exhibits painting in
group show, Corcoran Gallery of Art, Washington, D.C. By
now is a serious sculptor, but continues his lifelong
involvement with painting, watercolor, and colored drawing.

1933
Rents 61st Street studio in Lincoln Arcade and works there
through 1943. Exhibits paintings in group shows at Philadel-
phia Art Alliance and Corcoran Gallery of Art; and *Paint-
ings, Sculpture, Drawings, Prints on the Theme Hunger-
Fascism-War*, John Reed Club Gallery, New York. Works on
wood and stone carvings. Begins to use Ferber, his middle
name, as his artist's name.

1934
Coauthors scholarly paper for *Journal of Dental Research*,
February. Meets Wassily Leontief, Nobel laureate in
economics, through poet Estelle Leontief, a childhood
friend. Also meets members of the Frankfurt School who had
left Germany and had become associates at Columbia,
including sociologists Leo Lowenthal and Herbert Marcuse
and the philosopher Max Horkheimer, and attends their
seminars.

1935
Leaves Kleeman and Hudson Galleries and joins Midtown
Galleries. Exhibits sculpture in group show, Midtown
Galleries. Drives to Mexico, first of several trips there. Buys
pre-Columbian sculptures. Returns via Chicago and Stone
City, Iowa, where he teaches stone carving at Grant Wood's
school for two weeks.

1936
Exhibits sculpture in group show, Midtown Galleries.
Participates in and exhibits at the First American Artists'
Congress (also 1940). Joins the Artists' Union; attends talks
by José Orozco and David Siqueiros there and at the John
Reed Club.

1937
Has one-man show, Midtown Galleries, December 7–20.
Featured in *Time* magazine article.

1938
Travels in Europe for two months during summer. Leaves
Rome after short stay due to Fascist situation. In France,
sketches Romanesque sculpture at Moissac, Carcassonne,
and Souillac. Exhibits in group show at the Jeu de Paume,
Paris, sponsored by and also later shown at The Museum of
Modern Art, New York. Exhibits in group shows at The
Baltimore Museum of Art; the Museum of Modern Art
Gallery, Washington, D.C.; the Sculptors' Guild (also
1939–1942, 1948); and the Whitney Museum of American
Art *Annual Exhibition of Contemporary American Painting
and Sculpture* (also 1940, 1942, 1945, 1954, 1956–1960,
1964, 1966, 1968).

(Ferber showed sculpture in all exhibitions mentioned hereafter, except where noted.)

1939

Exhibits at the Golden Gate International Exposition, San Francisco.

1940

Exhibits at New York World's Fair. With Meyer Schapiro, Adolph Gottlieb, Mark Rothko, Ilya Bolotowsky, Bradley Walker Tomlin, David Smith, and others, founds Federation of Modern Painters and Sculptors as a splinter group from American Artists' Congress.

1941

Elected to executive board, Sculptors' Guild, along with Chaim Gross, Robert Laurent, and Hugo Robus. Shows at the *52nd Annual Exhibition of American Paintings and Sculpture*, The Art Institute of Chicago (also 1954).

1942

Awarded $1,000 Fifth Purchase Prize, The Metropolitan Museum of Art *Artists for Victory* exhibition.

1943

Has one-man show, Midtown Galleries, May 17–June 4. Divorces. Moves to penthouse studio-apartment on Riverside Drive.

1944

Marries Ilse Falk, historian of medieval art. Makes last wood sculptures.

1945

Draws abstract studies, but does no sculpture for almost a year, then begins again with semi-abstract work in various media. Rents house in Barton, Vermont; spends summers there until 1972.

1946

Joins Betty Parsons Gallery. Milieu includes members of adjacent Samuel Kootz Gallery. Becomes friendly with Jackson Pollock, Adolph Gottlieb, Robert Motherwell, Ad Reinhardt, William Baziotes, Bradley Walker Tomlin, Theodore Stamos, and particularly Mark Rothko. Participates in gathering of these artists along with Alfred Barr, Dorothy Miller, George Dennison, Meyer Schapiro, Robert Goldwater, Sam Hunter, E. C. Goossen, Herbert Marcuse, and Leo Lowenthal. Exhibits model of relief for exterior of Kleinhaus Music Hall, Buffalo, in *Architecture Needs Sculpture* at the Sculptors' Guild, his first work in architectural sculpture.

1947

Has one-man show, Betty Parsons Gallery, December 15, 1947–January 3, 1948. Participates in the Art Students League Second Annual Forum. Exhibits in *Abstract and Non-Objective Sculpture*, Clay Club Sculpture Center.

1948

Elected full member, Kappa Chapter (Columbia University), Society of Sigma Psi. August–October, travels in England, where he visits Henry Moore and spends time with composer Richard Arnell; France (through Burgundian Romanesque region); and Italy, where he studies Donatello's Campanile

Prophets. Participates in Studio 35 activities. Exhibits in *Sculpture at the Crossroads* (Henry Rox, organizer), Worcester (Massachusetts) Art Museum.

1949

Presents talk at Subjects of the Artist School and speaks on panel at the Art Students League Fourth Annual Forum.

1950

Has one-man show, Betty Parsons Gallery, March 6–25, installation designed by Tony Smith. Joins "The Irascibles" in a protest against a juried painting exhibition at The Metropolitan Museum of Art. Featured in *Life* magazine. Presents talk at the New York Architectural League. Charter member, The Club.

1951

The Museum of Modern Art purchases *Jackson Pollock*. Exhibits in *I. São Paolo Biennal*, Brazil; *Abstract Painting and Sculpture in America* (Andrew Carnduff Ritchie, curator), The Museum of Modern Art; and *9th Street Show* (Leo Castelli, organizer). Commissioned together with Gottlieb and Motherwell for art for B'nai Israel Synagogue in Millburn, New Jersey.

1952

Robert Goodnough publishes "Ferber Makes a Sculpture" in *Art News*, November. Exhibits in *15 Americans* (Dorothy Miller, curator), The Museum of Modern Art (others include Baziotes, Richard Lippold, Pollock, Rothko, Clyfford Still, and Tomlin). Participates in The Museum of Modern Art's "Symposium on the New Sculpture" with David Smith, Lippold, and Roszak. "*. . . And the bush was not consumed,*" begun March 1951, installed at B'nai Israel Synagogue (Percival Goodman, architect); assisted by Tony Louvis, assembles work in Day Schnabel's studio.

1953

Has one-man show, Betty Parsons Gallery, April 20–May 9. Award winner, Unknown Political Prisoner Monument Competition (Andrew Ritchie, Perry Rathbone, Seymour Swarzenski, jurors); subsequent showings at The Museum of Modern Art and the Tate Gallery, London.

1954

Designs light and candelabrum for Berlin Chapel, Brandeis University (Max Abramowitz, architect). Participates in panel, College Art Association Annual Meeting, Philadelphia. Makes first roofed sculptures which led to sculpture as environment, 1959–1961.

1955

Has one-man show, Samuel Kootz Gallery, January 25–February 12. Participates in "Symposium on Art and Music," Bennington College (Vermont). Exhibits in *The New Decade: 35 American Painters and Sculptors* (John I. H. Baur, curator), Whitney Museum of American Art; exhibition travels to San Francisco, Los Angeles, St. Louis, and Denver. Devotes considerable amount of time to painting for the next three years.

1956

Robert Goldwater writes on Ferber for *Cimaise* magazine, Paris/New York. Meets William S. Rubin, then professor of art history, Sarah Lawrence College.

1957

Has one-man show, Samuel Kootz Gallery, December 3–21. Two interior wall sculptures installed, Temple Anshe Chesed, Cleveland (Percival Goodman, architect). Exhibits in *Irons in the Fire*, Contemporary Arts Museum, Houston (Sam Hunter, curator).

1958

Retrospective exhibition, Bennington College (E. C. Goossen, director; Robert Goldwater, catalogue introduction). Exhibits at Brussels World's Fair, U.S. Pavillion, in *Carnegie International*, Pittsburgh, and *Nature in Abstraction* (John I. H. Baur, curator), Whitney Museum of American Art. In summer, concentrates on painting large canvases.

1959

Three American Sculptors, with text on Ferber by E. C. Goossen, published. Exhibits in *Documenta II*, Kassel, West Germany. Begins to make maquettes of *Sculpture as Environment*. Also concentrates on large paintings.

1960

Has one-man painting show, André Emmerich Gallery, January 5–23. Has one-man show, Avery Hall, School of Architecture, Columbia University. Lectures on "Sculpture as Environment," Princeton University and Columbia School of Architecture. Exhibits in *Aspects de la sculpture américaine*, Galerie Claude Bernard, Paris.

1961

Exhibits *Sculpture as Environment*, commissioned by Whitney Museum of American Art. Participates in symposium at the New School for Social Research.

1962

Retrospective exhibition organized by Wayne V. Andersen for the Walker Art Center, Minneapolis; exhibition travels to Des Moines, San Francisco, Dallas, Santa Barbara, and the Whitney Museum of American Art, New York. Visiting professor of art, University of Pennsylvania. Exhibits in *Sculptures in the City*, Festival of Two Worlds, Spoleto; *American Art Since 1950* (Sam Hunter, curator), Seattle World's Fair; *A Survey of American Sculpture: Late 18th Century to 1962* (William Gerdts, curator), The Newark Museum; and "Art in Embassies" program, Warsaw.

1963

Has one-man show, André Emmerich Gallery, April 2–20. Commissioned by Harlow Carpenter to design full-scale outdoor sculpture and architecture as an environment, Waitsfield, Vermont (project is unrealized). Juror, *54th Annual Exhibition*, Museum of Art, Carnegie Institute, Pittsburgh. Exhibits in *Sculpture in the Open Air*, Battersea Park, London.

1964

Has one-man show, Robert Hull Fleming Museum, University of Vermont, Burlington. Juror, sculpture exhibition, National Gallery of Canada, Ottawa. Exhibits at the New York World's Fair and in *Between the Fairs: 25 Years of American Art* (John I. H. Baur, curator), Whitney Museum of American Art.

1965

Has one-man show, André Emmerich Gallery, January 5–23. Moves studio to 825 Broadway. Visiting professor of sculpture, Rutgers University, through 1967. Rutgers University commissions 18-foot sculpture for Commons Building. Participates in the White House Festival of the Arts. Exhibits in *Etats-Unis, sculptures du XXᵉ siècle*, Musée Rodin, Paris, sponsored by the International Council of The Museum of Modern Art; exhibit travels to Berlin and Baden-Baden.

1966

Sculpture as Environment installed in Ferber Lounge, Rutgers University. Juror, *Sculpture '66*, University of Illinois, Chicago. Participates in sculpture symposium at The University of Texas, Austin, with Louis Kahn, James Rosati, and George McNeil. Exhibits in *Art of the United States: 1670–1966*, Whitney Museum of American Art, celebrating opening of new building, and *7 Decades: 1895–1965* (Peter Selz, organizer), Public Education Association, New York.

1967

Has one-man show, André Emmerich Gallery, February 11–March 2. Associate fellow, Morse College, Yale University. Divorces. Marries Edith Popiel.

1968

Installs *Full Circle*, John F. Kennedy Federal Building, Government Center, Boston. Tapes interview for Archives of American Art with Irving Sandler. Temporary installation of *Three Arches* at Fifth Avenue and 59th Street. Exhibits in *Dada, Surrealism, and Their Heritage* (William S. Rubin, curator), The Museum of Modern Art, and at HemisFair '68, San Antonio.

1969

Awarded a Guggenheim Fellowship. Exhibits in *The New American Painting and Sculpture: The First Generation* (William S. Rubin and William C. Agee, curators) and *Nelson Aldrich Rockefeller Collection of 20th-Century Art*, both at The Museum of Modern Art.

1970

Has one-man show, André Emmerich Gallery, November 14–December 2. Moves household and studio to MacDougal Street. Delivers eulogy at his friend Mark Rothko's funeral. Appointed guardian for daughter Kate Rothko and executor of estate of Mrs. Mark Rothko.

1972

Has one-man show, André Emmerich Gallery, November 11–29. Has one-man show, Hammarskjöld Plaza, New York, May–July. Purchases house and studio in Berkshires, North Egremont, Massachusetts, for summers and holidays. Initiates Rothko lawsuit on behalf of Kate Rothko.

1973

Installs 22-foot-high sculpture, American Dental Association headquarters building, Chicago. Exhibits in *American-Type Sculpture* (Phyllis Tuchman, curator), School of Visual Arts Gallery, New York, and in *Sculpture of the '50s*, Santa Barbara Museum of Art.

1974

Publishes Gottlieb obituary, *New York Times*. Exhibits in *Monumenta* (Sam Hunter, curator), Newport, Rhode Island.

1975

Has one-man show, André Emmerich Gallery, January 11–29. Has one-man painting show, André Emmerich Gallery, September 17– October 8. Participates in panel discussion, School of Visual Arts, with Ibram Lassaw, Joel Perlman, Peter Reginato, and Tuchman. Visits Egypt.

1976

Exhibits in *200 Years of American Sculpture* (in section organized by Rosalind E. Krauss), Whitney Museum of American Art.

1977

Has one-man painting show, André Emmerich Gallery, February 26– March 16. Gives up part-time dental practice; continues to teach part-time at Columbia University Dental School. Tours Greece with Leontiefs.

1978

Has one-man shows, M. Knoedler & Co., Inc., April 1–20, and Roy Boyd Gallery, Chicago, November 3–December 6. Installs 18-foot sculpture commissioned in 1977 by city of Ottumwa, Iowa. Included in *Masters of Modern Sculpture, Part Three*, a Michael Blackwood film. Exhibits in *Painting and Sculpture Today*, Indianapolis Museum of Art, June 12–July 30, and in *Art for Collectors*, The Toledo Museum of Art, November 12–December 17.

1979

Has one-man show, M. Knoedler & Co., Inc., March 10–29. Awarded R. S. Reynolds Memorial Award for aluminum sculpture for 1979. Exhibits in *Vanguard American Sculpture: 1913–1939* at Rutgers University. Occupies Mellon Chair in the Humanities at Rice University, Houston, in fall.

1980

Has one-man show, M. Knoedler & Co., Inc., April 19–May 10.

1981

Has one-man show, M. Knoedler & Co., Inc., March 14–April 2. Retrospective exhibition at The Museum of Fine Arts, Houston, May 1–June 28, and Des Moines Art Center, November 23, 1981–January 3, 1982.

1982

Has one-man show, M. Knoedler & Co., Inc., March 13–April 1.

1983

Has one-man show, M. Knoedler & Co., Inc., March 12–March 31.

1984

Has retrospective of sculpture and drawings (1932–1983) at The Berkshire Museum, Pittsfield, Massachusetts, June 2–July 29 (organized by Debra Bricker Balken).

1985

Has one-man show of sculpture of the 1950s and 1960s, M. Knoedler & Co., Inc., April 13–May 2.

1986

Has one-man show of Semaphora Series—Wall sculpture, M. Knoedler & Co., Inc., March 1–20.

1987

Has one-man show of new paintings, M. Knoedler & Co., Inc., December 2–January 2.

Has one-man show of drawings, Studio d'Arte Fanussi, Milan, Italy, May 13–June 30.

1989

Has one-man show of sculpture, M. Knoedler & Co., Inc., March 4–23.

1990

Has one-man show, M. Knoedler & Co., Inc., September 6–October 4.

1991–92

Dies August 25, at summer home in North Egremont, Massachusetts.

Has one-man show of sculpture and painting from the last ten years, M. Knoedler & Co., Inc., December 4–January 2.

Reprinted from Phyllis Tuchman's chronology in Herbert Ferber Sculpture, Painting, Drawing: 1945–1980, *exh. cat. (Houston: The Museum of Fine Arts, 1983) pp. 40–43.*

1903
Born on November 6 in New York City.

1921
Graduates from Morris High School, where he was active in drawing, poster and art clubs, and school publications.

1921–23
Attends Brooklyn Polytechnic Institute, then College of the City of New York before entering Columbia University. Begins to read widely in art history and aesthetics.

1927
Receives degree from Columbia University.

1928–29
Interests concentrate on sculpture. Models clay portrait heads of friends and members of family, carves a marble head in deep relief, also some ornaments in ivory and gold.

1930
Marries Lillian Franzblau on November 16.

1930's
Devotes an increasing amount of time to sculpture, working on his own in direct plaster and carving in wood.

1933–34
Exhibits for first time in group show at John Reed Club Gallery, New York, where he shows his first wood carving, *Lynched.* First son, Michael, is born in January.

1938
First one-man show (wood sculptures) at the ACA Gallery, New York.

1940
Exhibits at World's Fair and in the American Artists' Congress show, New York.

1940–65
Teaches sculpture at the New School for Social Research, New York.

1941–44
Exhibits in the Sculptors' Guild Show, New York.

1942
Second son, Alan, is born in July.

1943
One-man show at St. Etienne Gallery, New York, includes bronze castings in abstract metaphorical style. Participates in group shows at Buchholz Gallery and others in New York. Teaches at the Cooper Union, New York.

1944–46
Begins sheet-lead construction technique. Teaches at New Jersey State Teachers College, Newark. Exhibits in many group shows.

1946
Exhibits in Whitney Museum of American Art *Annual Exhibition of Contemporary American Painting and Sculpture,* New York. (Has exhibited in all subsequent Annuals to date).

1947
Begins working in lead-soldered sheet steel and also in combined wood and metal media. Exhibits in various museum shows, including the *58th Annual Exhibition of American Painting and Sculpture* at the Art Institute of Chicago.

1948
One-man show at Betty Parsons Gallery, New York. (Other one-man shows there in 1950, 1952, 1954, 1958, and 1961.) Exhibits in museum shows in New York and throughout the U.S.

1949
Begins technique of brazing (melting) brass rods onto sheet steel with the oxyacetylene torch.

1949–52
Exhibits in various museum group shows.

1950
Arrives at signature, or mature, style.

1951
One-man show at the American University, Washington, D.C. Exhibits in *Abstract Painting and Sculpture in America* at The Museum of Modern Art, New York.

1953
Receives commission from architect Percival Goodman for three sculptures for Temple Israel in Tulsa, Oklahoma. Sound film, *Sculpture by Lipton,* produced by Nat Boxer.

1954
Sanctuary acquired by The Museum of Modern Art, New York.

1955
Makes transition from brazing on sheet steel to brazing on sheet Monel metal. One-man show at University Teachers College in New Paltz, New York. Receives commission from Percival Goodman for five works for Temple Beth El in Gary, Indiana. Works included in two Museum of Modern Art traveling exhibitions, one shown throughout the U.S., the other in Europe. Exhibits in Whitney Museum of American Art show *The New Decade—35 American Painters and Sculptors.* 1954 one-man show at Betty Parsons Gallery cited by *Art News* as one of the ten best shows of the year.

1956
Exhibits in *12 Americans* at The Museum of Modern Art, New York. One-man show at museum of Munson-Williams-Proctor Institute, Utica, New York, where he is also visiting artist. Exhibits at various museums, including the Des Moines Art Center, Iowa, and the Museé Rodin in Paris.

1957

Pioneer acquired by The Metropolitan Museum of Art, New York. Wins first prize (Logan Award) at the Art Institute of Chicago for *The Cloak*, and top acquisition prize in one-man show at São Paulo Biennale, Brazil. Receives commission from Skidmore, Owings and Merrill for *Hero* for the Inland Steel Company Building in Chicago. Exhibits in the USIA worldwide traveling show, *8 American Artists*.

1957–59

Visiting critic at the Yale Art School, New Haven, Connecticut. Various commissions and museum acquisitions.

1958

One-man show at Venice Biennale, Italy.

1959

Exhibits in group shows, including Carnegie International in Pittsburgh; two shows at Whitney Museum of American Art, New York, *Nature in Abstraction* and the *Friends of the Whitney*; sculpture show at the Galerie Claude Bernard in Paris; and the USIA *American National Exhibition of Painting and Sculpture* in Moscow (also later shown at the Whitney Museum).

1960

Receives Guggenheim Award; Architectural League Award for *Hero*; New School for Social Research Purchase Award for *Viking*. Exhibits at *11 Documenta* in Kassel, Germany.

1961–62

Receives commission from architect Eero Saarinen for two sculptures (*Argonaut I* and *II*) for IBM Watson Research Center in Yorktown Heights, New York. These receive two Architectural League Awards: for best sculpture and for best sculpture in relation to architecture. Ford Foundation Award. Award from Perini-San Francisco (architects) for *Chinese Bird*. One-man show at Rensselaer Museum in Troy, New York. Exhibits in numerous group shows, including the International at Spoleto, Italy.

1963–64

Commissioned by architect Max Abramowitz for *Archangel* for Philharmonic Hall of Lincoln Center, New York. Sound film *Archangel* produced by Nat Boxer. Large one-man show of sculpture and drawings at the Phillips Collection, Washington, D.C. Various museum group shows.

1965

Manuscript acquired by The Museum of Modern Art, New York. One-man show at Marlborough-Gerson Gallery, New York. Exhibits in group shows including the European traveling show *Sculpture of the 20th Century*, *The White House Festival of the Arts*, Washington, D.C., and others in the U.S. and abroad.

1966

Exhibits in group shows including *Art of the United States: 1670–1966* at the opening of the new Whitney Museum of American Art, New York, and other shows throughout the U.S. Tapes interviews for Archives of American Art, New York.

1967

Receives commission from Milwaukee Performing Arts Center, Wisconsin, for large outdoor sculpture, *Laureate*. Is appointed sculptor member of the Fine Arts Commission of the City of New York by Mayor John V. Lindsay.

1967–68

Tapes interviews for Archives of American Art and for Archives of The Brooklyn Museum of Art, New York. Exhibits in group shows in the U.S. and abroad. Various commissions and museum acquisitions.

1968

Wins first prize, George D. Widener Gold Medal, for *Gateway* in *The 163rd Annual Exhibition of American Painting and Sculpture* at the Pennsylvania Academy of the Fine Arts, Philadelphia. *Imprisoned Figure* (1948) is included in The Museum of Modern Art, New York, show *Dada, Surrealism, and Their Heritage*. Exhibits in other group shows in the U.S. and abroad.

1969

Large one-man exhibition, Milwaukee Art Center. The Museum of Modern Art, New York, exhibits five sculptures in two major shows.

1970

Monograph by Albert Elsen published by Harry N. Abrams, New York.

1972

Virginia Museum of Fine Arts, Richmond organizes one-man exhibition.

1975

Elected member of the National Institute of Arts and Letters, New York.

1977

Honored at New Orleans International Sculpture Society.

1978–84

National Collecton of Fine Arts acquires *Defender*. One-man exhibitions organized by the National Collection of Fine Arts, Washington, D.C., 1979; Mint Museum, Charlotte, North Carolina, 1982; and Long Island University, Greenvale, New York, 1984.

1985

Lillian Franzblau, his wife of 55 years, dies.

1986

Dies on December 7.

Reprinted, in part, from Albert Elsen, Seymour Lipton *(New York: Harry N. Abrams, 1970), compiled by Jerome Weidman.*

1904–1917

Born in Los Angeles, November 17, 1904, to Japanese poet Yone Noguchi and American writer Leonie Gilmour. Moves to Japan in 1906; attends Japanese and Jesuit schools. Sister Ailes, born in 1912.

1918–1922

Sent to Interlaken School near Rolling Prairie, Indiana. School becomes army training camp; attends public high school in La Porte, Indiana, having been befriended by former Interlaken director, Dr. Edward Rumley. Rumley arranges apprenticeship with sculptor Gutzon Borglum, who says Noguchi will never be a sculptor.

1923–1926

Enrolls in Columbia University as premed student. Takes sculpture classes at Leonardo da Vinci Art School; encouraged by director Onorio Ruotolo, decides to become a sculptor. Mother returns to United States after seventeen years in Japan. He exhibits in academic salons; frequents avant-garde art galleries (Alfred Stieglitz's An American Place and the New Art Circle of J. B. Neumann and the Brummer Gallery, where he is impressed by Brancusi show). Sets up studio at 124 University Place.

1927–1929

Receives Guggenheim Fellowship for trip to Far East. Goes to Paris; serves as Brancusi's studio assistant for some months. Makes wood, stone, and sheet-metal abstractions that he exhibits upon his return to New York—first one-man show. Makes portrait busts to support himself; exhibits them successfully. Meets R. Buckminster Fuller and Martha Graham.

1930–1932

Returns to Paris and travels to Peking via the Trans-Siberian Railroad. Stays several months studying brush drawings with Chi Pai Shih, and then goes to Japan. Impressed by *haniwa* and Zen gardens; works in clay with potter Jinmatsu Unō. Returns to New York; exhibits terra-cottas and brush drawings. Develops contacts with socially conscious artists; first involvement with theater.

1933–1937

First designs for public spaces, monuments, and a playground, *Play Mountain* (all unrealized). Works briefly for Public Works Administration. Exhibits project ideas and socially conscious sculpture. First theater set, *Frontier*. Does portraits in Hollywood to finance stay in Mexico; executes mural about Mexican history. Returns to New York.

1938–1942

First fountain, Ford Fountain. Wins Treasury Section competition for Associated Press Building plaque. Designs playground and playground equipment (unrealized). Drives cross-country with Arshile Gorky. Voluntarily spends months in Japanese-American relocation camp, Poston, Arizona, in order to create landscape environments (unrealized).

1942–1948

Returns to New York; takes studio at 33 MacDougal Alley. Makes mixed-media construction, "landscape" reliefs, series of carved/constructed stone slab sculptures, self-illuminating pieces (Lunars). First manufactured furniture and lamp designs, distributed by Herman Miller and then Knoll. Extensive involvement with theater. First major exhibitions since 1935. Designs public spaces and a monumental earthwork, *Sculpture to Be Seen from Mars* (unrealized).

1949–1952

Receives Bollingen Foundation Fellowship to research book on leisure. Travels throughout Europe, Middle East, and Asia, and documents journey with photographs and drawings. Does last portraits. In Japan, marries the actress Yoshiko Yamaguchi, whom he had met earlier in New York. Does first realized garden, Reader's Digest, and interior (at Keiō University). Begins designing Akari. Works with potter Rosanjin Kitaoji; sets up studio on his land in Kamakura. Exhibits ceramics in Japan.

1952–1956

Commutes between New York and Japan. Separates from wife and they are later divorced. Designs United Nations Playground and first plaza, for Lever House (both unrealized). Exhibits clay sculptures at Stable Gallery; Eleanor Ward remains dealer until 1961. Exhibits Akari at Bonniers in New York. Does series of cast-iron pieces in Japan. Continues involvement with theater. Begins series of sculptures in Greek marble.

1956–1961

Continues Greek marble pieces. Executes the gardens for Connecticut General Life Insurance Company, which include a large sculptural grouping called *The Family*, the first in a long series of realized environmental projects that also initiates his work with architect Gordon Bunshaft of Skidmore, Owings & Merrill. Concurrently does UNESCO gardens in Paris. Exhibits environmental designs and iron and marble sculptures in New York. Works in sheet aluminum. Exhibits metal and balsa-wood pieces at Cordier & Warren Gallery. Arne Ekstrom remains his dealer until 1974. Executes first plaza, for First National City Bank, Fort Worth. Establishes studio in Long Island City, New York.

1962–1966

With architect Louis Kahn, designs series of models for Riverside Drive Playground (unrealized). Executes gardens for Chase Manhattan Bank, New York City; Beinecke Library, Yale University; IBM; and the Israel Museum; as well as first realized playground, Kodomo No Kuni in Tokyo. Does series of floor sculptures and multipart bronzes exhibited in 1963. Begins working in stone quarries of Querceta, Italy. First one-man show in Paris, 1964, at the Claude Bernard Gallery. Exhibits series of marble and granite pieces in 1965. Last stage set designed in 1966.

1967–1970

Exhibits stone/metal sculptures. Whitney Museum of American Art retrospective in 1968; concurrent exhibition of

brush drawings. Publishes autobiography, *A Sculptor's World.* Makes public sculptures for New York: *Red Cube;* Spoleto, Italy: *Octetra;* Seattle: *Black Sun;* Bellingham, Washington: *Skyviewing Sculpture.* Executes fountains for Expo '70, Osaka, Japan. Exhibits Akari and striped marble pieces made in Italy.

1971–1979
Establishes studio in Mure on Japanese island of Shikoku. Exhibits in London, Zurich, and New York galleries. Begins ongoing series of granite and basalt sculptures. Executes major plaza in Detroit (Philip A. Hart Plaza) including large-scale fountain, and several fountains for Supreme Court in Tokyo, Society of the Four Arts in Palm Beach, the Art Institute of Chicago. Does first United States playground (Playscapes in Atlanta, sponsored by the High Museum) and several pieces of public sculpture: *Void,* Pepsico, Purchase, New York; *Shinto,* Bank of Tokyo, New York City; *Landscape of Time,* Seattle Federal Building; *Sky Gate,* Honolulu Municipal Building; *Heaven,* interior garden and granite pylon for Sōgetsu Flower Arranging School, Tokyo; *Momo Taro,* Storm King Art Center, New York; *Spirit's Flight,* Meadows Museum, Dallas; proposal for garden at Houston Museum of Fine Arts. Acquires building across the street from Long Island City studio and renovates it for additional storage for his work. Exhibits sheet-metal sculptures at the Pace Gallery and Akari at the Museum of Modern Art. Major traveling exhibition of landscapes and sets initiated by the Walker Art Center. First monograph, *Isamu Noguchi* by Sam Hunter, published 1978.

1980–1981
Documentary film about artist and work made by Bruce Bassett, shown on PBS. Whitney Museum of American Art exhibits landscape projects and theater sets, *The Sculpture of Spaces.* Joint exhibitions at the Pace and Emmerich galleries to celebrate seventy-sixth birthday. Show includes new stone sculptures and table/landscape sculptures. Complete catalog of work written by Nancy Grove and Diane Botnick, published 1980. Establishes Isamu Noguchi Foundation, Inc. *Shinto* is dismantled by Bank of Tokyo. *Memorial to Benjamin Franklin,* a large-scale public sculpture proposed in 1933, is reproposed to the Philadelphia Museum of Art for the city of Philadelphia by the Fairmount Park Art Association. *The Spirit of the Lima Bean,* a granite sculpture, is erected as first part of an overall landscape project in Costa Mesa, California, *California Scenario.* Three basalt sculptures erected at the Cleveland Museum of Art. Proposal for a plaza with sculpture for the Japanese American Cultural and Community Center in downtown Los Angeles. Proposal for twenty-eight-acre park for the redevelopment of Bayfront Park in Miami. Acquires corner property adjacent to his building in Long Island City. Proposes an extension to the Vernon Boulevard building.

1981–1983
Work is started on what becomes the Isamu Noguchi Garden Museum. Noguchi designs new building extension and enlarges the garden. *California Scenario* is completed. The plaza and the sculpture *To the Issei* for the Japanese American Cultural and Community Center in Los Angeles is completed. Makes a series of twenty-six hot-dipped galvanized steel sculptures in editions, working with Gemini G.E.L. in 1982. Work is completed on museum in April 1983. Work is started on a garden museum at Noguchi's studio in Shikoku, Japan. *Constellation for Louis Kahn,* a major public sculpture at the Kimbell Art Museum, Fort Worth, Texas, installed in 1983. Water garden completed for the Domon Ken Museum in Japan, summer 1983.

1984
Receives honorary doctorate from Columbia University. Searches for a site for his *Memorial to the Atomic Dead,* originally proposed in 1952. *Monument to Ben Franklin* installed. Receives the New York State Governor's Arts Award and the Japanese American Citizens League Biennium Award. Celebrates his eightieth birthday in Japan with an exhibition of his Akari at the Sōgetsu Kaikan in Tokyo.

1985
January exhibition of Akari and new stone sculptures at the Seibu department store in Tokyo, installed by Arata Isozaki. In May, the Isamu Noguchi Garden Museum in Long Island City is formally opened to the public. Continues work on Bayfront Park in Miami and the sculpture garden for the Museum of Fine Arts, Houston. Receives the Israel Museum Fellowship in Jerusalem. Invited to represent the United States at the Venice Biennale in 1986 to be curated and organized by Henry Geldzahler and P.S. 1. Begins work on a large marble slide and new Akari designs for this exhibition.

1986
Exhibits seven large stone sculptures at the Pace Gallery in April. Sculpture garden for the Museum of Fine Arts, Houston, is completed and dedicated. The American Pavilion at the Venice Biennale opens in June. Noguchi shows new Akari, bronze playground models, and three large stone sculptures, including a ten-foot-high marble slide, originally conceived in 1966. Receives the Kyoto Prize from the Inomori Foundation in Japan in November. A memorial to the *Challenger* shuttle is proposed for Bayfront Park in Miami.

1987
The Isamu Noguchi Garden Museum catalog is published. Receives the National Medal of Arts, presented by President Ronald Reagan. Begins work on new constructed bronze sculptures.

1988
Begins designing three-hundred-acre park for city of Sapporo and approach and monument for airport at Takamatsu, Japan. Exhibits retrospective of bronzes at the Pace Gallery and recent bronze constructions at the Arnold Herstand Gallery in New York in May. Receives Third Order of the Sacred Treasure from the Japanese government in July and the first Award for Distinction in Sculpture from the Sculpture Center in December. Dies in New York, December 30.

Reprinted from Dore Ashton, Noguchi East and West *(New York: Alfred A. Knopf, 1992).*

THEODORE ROSZAK

1907
Born on May 1 in Poznan, Poland.

1909
Family moves to the United States and settles in Chicago, where there is a large Polish community. Roszak later attends public schools and, with his mother's encouragement, begins to make drawings.

1920
Wins the National Art Contest for Public Schools, sponsored by the *Chicago Herald-Examiner,* with a drawing of a fire engine.

1922
Attends evening classes at the School of the Art Institute of Chicago.

1924
Graduates from high school and becomes a full-time day student at the School of the Art Institute of Chicago. Wins awards for oil paintings and lithographs.

1925
Produces *My Violin Teacher,* a charcoal study that establishes his proficiency as a draftsman.

1926
Travels to New York. Studies briefly with Charles Hawthorne at the National Academy of Design, then begins private instruction with George Luks. Enrolls in philosophy courses at Columbia University.

1927–28
Returns to Chicago and resumes studies at the Art Institute with John Norton. Joins faculty as a part-time instructor of drawing and lithography. Awarded an American Traveling Fellowship of $250, which enables him to visit museums on the East coast and to practice lithography in Woodstock, New York. Upon his return to Chicago, appointed full-time instructor of drawing and lithography at the Art Institute.

1929–30
Supported by a $1500 Anna Louise Raymond Fellowship for European Study, spends eighteen months abroad. Paints out of a studio in Prague and visits Paris and other cities in Italy, Austria, and Germany. Discovers the work of Giorgio de Chirico. Attends the Exhibition of Contemporary Culture in Brno, Czechoslovakia. Introduced to Bauhaus ideology by Czech industrial artists and Moholy-Nagy's *The New Vision.* Acquires an appreciation of Cubism, Surrealism, and Constructivism. Returns to New York and the Depression.

1931
Awarded the Tiffany Foundation Fellowship, which enables him to live and work for two months at the Tiffany Foundation in Oyster Bay on Long Island, New York. Marries Florence Sapir and settles in Staten Island, New York.

1932–33
Works out of his small Staten Island studio producing paintings, sculptures, and drawings. Takes a machine-shop course in making and using tools. Begins to photograph his work and himself, and models, in plaster, a series of freestanding and relief sculptures, which become the basis of some of his first constructions—*Crescent Throat, Airport Sentinel,* and *Pierced Bipolar*—in thin-gauged sheet metal, brass, copper, and aluminum. Exhibits in the *First Biennial Exhibition of Contemporary American Painting* at the Whitney Museum of American Art, New York.

1934
Moves to 241 East Thirty-third Street in Manhattan, where he establishes a studio. Finds employment through government-sponsored projects instituted by the Works Progress Administration. Buys a lathe and begins to devote more time to sculpture, creating pristine objects and reliefs reminiscent of the polished metal constructions of Bauhaus artists such as Moholy-Nagy, Rudolf Belling, and Oskar Schlemmer. Receives the Eisendrath Award for Painting from the Art Institute of Chicago.

1935
Whitney Museum of American Art purchases *Fisherman's Bride* (1934) out of their *Second Biennial Exhibition of Contemporary American Painting.* Given a large one-man exhibition—paintings, drawings, and works on paper—at the International Art Center of the Roerich Museum, New York.

1938–40
Joins the faculty of the Laboratory School of Industrial design, originally the Design Laboratory, a tuition-free school of design sponsored by the Works Progress Administration's Federal Art Project and opened in September 1935 under the directorship of architect-designer Gilbert Rohde, with an advisory board that included Walter Dorwin Teague, Raymond Loewy, and Moholy-Nagy. Teaches two- and three-dimensional design and an experimental workshop in materials. In between the closing of the school and teaching at Sarah Lawrence College, Bronxville, New York, works as an assistant to Norman Bel Geddes at the 1939/40 New York World's Fair, Flushing Meadows. Exhibits some thirty constructions in two simultaneous shows at the Julien Levy Gallery and Hugh Stix's Artists' Gallery. Hitler invades Poland.

1940–45
During the war, works at the Brewster Aeronautical Corporation, Newark, New Jersey, designing aircraft (including an experimental bomber) and teaching aircraft mechanics, and at the Stevens Institute of Technology, Hoboken, New Jersey, as a navigational and engineering draftsman. Encounters the wartime work of Jacques Lipchitz in several exhibitions at the Buchholz Gallery, New York. Executes an extended series of about sixty-five gouaches that become a transition from constructivist to welded-steel sculpture. Begins to investigate mythic and atavistic themes of death and destruction, invocation, totemism, ritualistic violence, and rites of passage.

1941–55

Teaches two- and three-dimensional design and sculpture at Sarah Lawrence College. Early on, meets the mythologist Joseph Campbell, who also teaches at the college.

1945

World War II ends. Disillusioned by Bauhaus-Constructivist utopianism and the devastation of atomic war. His shattered faith in science and technology is replaced by a renewed faith in nature, in change and transformation, and in archetypal motifs that reaffirm basic values. Begins welding steel with oxyacetylene torch. Jettisons the slick chromium sheen and machine-tooled precision of earlier constructions for spiky steel forms.

1946

Some transitional welded-steel sculptures included in Dorothy C. Miller's *Fourteen Americans* exhibition at the Museum of Modern Art, New York.

1947

Birth of daughter, Sara Jane, on August 26.

1947–48

Spectre of Kitty Hawk (1946–47)—bought by Alfred H. Barr, Jr. for the Museum of Modern Art, New York, in 1950—exhibited in the Art Institute of Chicago's *Fifty-Eighth Annual Exhibition of American Paintings and Sculpture*, organized around the theme of abstract and Surrealist American art. Awarded the Frank G. Logan Medal from the Art Institute of Chicago.

1951

Given first of several one-person exhibitions at the Pierre Matisse Gallery, New York. Receives the Purchase Award from the Museo de Arte Moderna, São Paulo, Brazil; the Frank G. Logan Medal from the Art Institute of Chicago; a Faculty Fellowship from Sarah Lawrence College.

1952

Executes maquette for "The Monument to the Unknown Political Prisoner," which is exhibited in New York and later entered in international competition. Commissioned to design the bell tower for Eero Saarinen's non-denominational chapel at the Massachusetts Institute of Technology, Cambridge. Receives the Purchase Award from the University of Illinois, Urbana; the American Award, International Competition, from the Museum of Modern Art, New York; the International Award from the Institute of Contemporary Art, London.

1956–57

Given a major traveling retrospective organized by the Walker Art Center, Minneapolis. Elected as a member of the Advisory Board of National Committee of Arts and Government (a position he holds until 1958). Receives the Widener Gold Medal Award for Sculpture from the Pennsylvania Academy of the Fine Arts, Philadelphia.

1959

Included in Peter Selz's *New Images of Man* exhibition at the Museum of Modern Art, New York. Receives Ford Foundation Grant.

1960

Commissioned by Eero Saarinen to fabricate a thirty-seven-foot, two thousand pound aluminum eagle for the front facade of the American Embassy in Grosvenor Square, London. Executes another eagle for the Federal Court House, New York.

1961

Elected a member of Advisory Committee on Cultural Presentations Program, State Department, Washington, D.C. (a position he holds until 1967).

1962

Elected a member of Board of Trustees, Tiffany Foundation; a member of Board of Governors, Skowhegan School of Painting and Sculpture, Maine; and a member of Fine Arts Commission, Washington, D.C. (a position he holds until 1966).

1964–65

Executes *Forms in Space*, installed in front of the Hall of Science at the New York World's Fair, Flushing Meadows. Elected a member of National Institute of Arts and Letters, New York. Participates in a symposium on higher education in Lima, Peru.

1968

Receives commission for a major sculpture—*Sentinel*—installed in the forecourt of the Public Health Laboratory Building, New York.

1969

Elected a member of Fine Arts Commission, New York (a position he holds until 1975).

1970–71

Guest critic at Columbia University, New York. Elected a member of Board of Trustees, American Academy in Rome (a position he holds until 1972).

1978

Zabriskie Gallery, New York, presents an exhibition of his constructions dating from 1932 to 1945.

1981

Dies in New York of heart failure on September 2.

Reprinted from Theodore Roszak: The Drawings, *exh. cat. (New York: The Drawing Society, Inc., 1992).*

DAVID SMITH

1906
Born on March 9 in Decatur, Indiana. Father, Harvey Martin Smith, is a telephone engineer and part-time inventor. Mother, Golda Stoler Smith, is a schoolteacher. Attends grade school and one year of high school in Decatur.

1911
Sister, Catherine, is born on April 7.

1921
Moves with his family to Paulding, Ohio, where his father is manager and part-owner of Paulding Telephone Company. Attends Paulding High School.

1923
Takes correspondence course in cartooning from Cleveland Art School.

1924
Spring—completes high school. Fall—enters Ohio University, Athens, for one year; takes art courses.

1925
Summer—works in South Bend, Indiana, as a welder and riveter at Studebaker plant. Fall—registers as a special student in Notre Dame University. Works for banking agency of Studebaker Finance Department, which transfers him to Morris Plan Bank in Washington, D.C.

1926
Moves to Washington, D.C. Lives at 1408 H Street, N.W. Summer—attends two poetry classes at George Washington University. Is transferred to New York City to work for Industrial Acceptance Corporation, West Fifty-seventh Street. Lives in a rooming house at 417 West 118th Street, where he meets Dorothy Dehner, a student at the Art Students League. Begins evening classes at the Art Students League with Richard Lahey.

1927
Early summer—transferred back to South Bend Studebaker office, then goes home at end of summer. Drives back to New York. Fall—becomes full-time student at the Art Students League (until 1932). Studies with Jan Matulka (until 1931), Allen Lewis, John Sloan, and Kimon Nicolaides; also makes prints. Works at various part-time jobs. December 24—marries Dorothy Dehner at City hall. Moves to 15 Abingdon Square in Greenwich Village.

1928
February–May—works for A. G. Spaulding, the sporting goods store. Spring—works as a seaman on an oil tanker going from Philadelphia to San Pedro, California. Summer—Dehner joins him in Los Angeles and they visit her aunt in Pasadena. Returns to Bayonne, New Jersey, on a tanker. Fall—returns to Spaulding (until October 1931); moves to apartment in Brooklyn on Myra Court (later Beekman Place), Flatbush. Visits artists Thomas and Weber Furlongs' farm at Bolton Landing near Lake George.

1929
Summer—visits the Furlongs for one month. Buys "Old Fox Farm" in Bolton Landing. Fall—moves to 163 Sterling Street, Flatbush. December—makes illustrations for *The Sportsman Pilot* (until 1931).

1930
Meets the artist John Graham about this time. Works free-lance for *Tennis* magazine on layouts (until 1931). March—included in first group exhibition, *Fourth Annual Exhibition of American Block Prints*, Print Club of Philadelphia. Paints in abstract Surrealist style. Sees reproductions of Picasso's and González's welded-metal sculpture in *Cahiers d'art*.

1931
Summer—studies in private class with Matulka. August—goes to Bolton Landing. October—goes to Saint Thomas in the Virgin Islands for eight months.

1932
Makes constructions of wood, coral, and wire. June—returns to New York, then to Bolton Landing. Moves to apartment at 124 State Street, Brooklyn Heights. Buys welding outfit and air-reduction oxyacetylene torch.

1933
Makes carved wood sculptures; makes first all-metal sculptures. Spring and summer—works at Bolton Landing making sculptures and welding. Fall—returns to New York and job at A. G. Spaulding. Makes series of welded and painted heads. Through John Graham gets job making bases for Frank Crowninshield's collection of African sculpture, which he helps catalog.

1934
Rents studio space at a machine shop called Terminal Iron Works, at 1 Atlantic Avenue, on the ferry terminal in Brooklyn (until 1940). March 22—assigned to Technical Division of Civil Works Administration, Public Works of Art Project, New York, mural painting project 89. August—becomes assistant project supervisor, Emergency Temporary Relief Administration (until July, 1935). John Graham gives him *Head*, by González. October—becomes member of Artists' Committee for Action for the Municipal Art Gallery and Center. Teaches for a few weeks at the Town School, New York City, for Lois Wright, the art teacher.

1935
Spring—signs a call for an American Artists Congress to be held February 1936. July 9—leaves the Temporary Relief Administration. October—takes first trip to Europe. Visits Brussels. Spends one month in Paris, where John Graham is buying African sculpture; makes etchings in Stanley Hayter's studio. Spends winter in Greece, where he has a studio at 26 Joseph Monferatu.

1936

Travels by boat from Piraeus to Marseilles, via Naples and Malta. Returns to Paris. May—visits London. Takes Russian steamer to Leningrad on twenty-one-day tour to Soviet Union. Visits John Graham's ex-wife and children. July 4 —returns to New York. Goes to Bolton Landing. Fall—returns to New York. Lives at 57 Poplar Street, Brooklyn. Makes first modeled wax pieces for bronze castings about this time.

1937

February—assigned to Works Project Administration Federal Arts Project (until August 1939). September 28—joins American Abstract Artists. Works on Medals for Dishonor series (until 1940). Works on oxyacetylene-welded sculpture. Makes sculptures for the WPA/FAP. Joins the Artists Union, Local 60, about this time.

1938

January—first solo exhibition, including both drawings and sculpture, opens at Marian Willard's East River Gallery. Summer—works at Bolton landing; makes lost-wax bronzes. Makes balsa sculpture for the WPA/FAP.

1939

February (1938?)—joins Sculpture Division of WPA, headed by Girolamo Piccoli. Joins the Sculpture Guild about this time. Commissioned by the Museum of Modern Art to make andirons and fireplace tools for the museum's penthouse. August 4—father dies; Smith attends funeral and makes bronze plaque for his headstone. Smith's work included in exhibition at New York World's Fair.

1940

Spring—moves to Bolton Landing permanently and names his studio there Terminal Iron Works. Works as machinist in Glens Falls. Lectures at United American Artists, New York.

1941

Studies welding at a wartime government school in Warrensburg, New York.

1942

Lives in three-room attic at 1113 McClellan Street, Schenectady. Studies welding at Union College. Works at night for the American Locomotive Company, assembling tanks and locomotives (until 1944); is rated a first-class welder. Joins the United Steelworkers of America, Local 2054, about this time; is rated first-class armor-plate welder by army ordinance. Returns to Bolton Landing on weekends. Works half-days at Harrington and Mallery, marble and granite workers, Saratoga.

1943

Commissioned by the Chinese government to design a medal for "China Defense Supplies," which was never made. Travels to Washington, D.C., for various conferences.

1944

March—classified 4-F by the United States Army. Quits job at Schenectady and moves back to Bolton Landing. Works on studio and design of new house; finishes studio workshop about this time.

1945

Is injured falling off a truck. Summer—Dehner returns to New York for five months.

1946

January–April—lives in New York City. May–December—lives in Bolton Landing. Begins Spectres series.

1947

August 29—speaks at First Woodstock Conference of Artists. Meets Robert Motherwell.

1948

October—teaches art at Sarah Lawrence College, Bronxville, New York (until 1950). Finishes building new house at Bolton Landing.

1949

Designs three prize medals for the Art News National Amateur Painters Competition. Designs bronze medal for the National Foundation for Infantile Paralysis, New York. With Dorothy Dehner attends all Bolton Landing town meetings, then runs unsuccessfully for Justice of the Peace.

1950

April—receives Guggenheim Foundation Fellowship (renewed 1951). Separates from Dorothy Dehner. Meets Helen Frankenthaler; meets Kenneth Noland through Cornelia Langer (later Noland's wife), a student of his at Sarah Lawrence.

1951

Begins Agricola series. February—substitute teaches at Sarah Lawrence College. October—included in *I Bienal de São Paulo*, his first foreign group exhibition.

1952

December 24—he and Dorothy Dehner are divorced. Begins Tanktotem series.

1953

January—*Artnews* votes Smith's 1952 exhibition one of the ten best shows of the year. Spring—is Visiting Artist for one semester in the art department at the University of Arkansas, Fayetteville.

April 6—marries Jean Freas of Washington, D.C. Continues to lecture at conferences and colleges.

1954

April 4—daughter Eva Athena Allen Katherine Rebecca is born. Makes silver sculpture for Towle Silversmiths, Newburyport, Massachusetts, for American Federation of Arts exhibition *Sculpture in Silver from Islands in Time*. June—included in *XXVII Venice Biennale*. September–June 1955—is Visiting Professor, Department of Fine Arts, at Indiana University, Bloomington. Visits Europe as delegate to UNESCO's First International Congress of Plastic Arts, Venice; travels in France and Italy.

1955

Teaches at University of Mississippi, Oxford, for one semester. August 12—daughter Candida Kore Nicolina Rawley Hellene is born. Begins making stencil drawings on paper.

1956
Makes new series of bronze plaques (until 1957). Begins Sentinel series.

1957
Commissioned by Art Institute of Chicago to design Mr. and Mrs. Frank C. Logan Medal.

1958
June—included in *XXIX Venice Biennale*. Begins to make stainless steel sculptures.

1959
September — wins prize at *V Bienal de São Paulo*. Begins Albany series.

1961
Begins Zig series. He and Jean Freas are divorced. October—refuses to accept third prize at Carnegie Institute, Pittsburgh International.

1962
May–July—goes to Voltri, near Genoa, Italy, to make sculpture for the Fourth Festival of Two Worlds at Spoleto. Makes twenty-seven works in thirty days. October—begins Circle series. December–March 1963—makes Voltri-Bolton series of twenty-five works from machine parts shipped from Italy.

1963
Begins stainless steel Cubi series. September–October—makes small painted Menands.

1964
Receives Creative Arts Award from Brandeis University. Interview held with Frank O'Hara on WNTD-TV: *David Smith: Welding Master of Bolton Landing*. Invited by Cleve Gray to make a limited edition ceramic piece for *Art in America* with David Gil of Bennington Potters.

1965
February—appointed member of National Council on the Arts. May 23—dies following an automobile accident near Bennington, Vermont.

Reprinted from Karen Wilken, David Smith *(New York. Abbeville Press, 1984). Chronology compiled by Anna Brooke.*

SELECTED BIBLIOGRAPHY

For each artist, bibliographical material is listed alphabetically by author, or, in the case of exhibition catalogues, by institution. Citations for the Archives of American Art, Smithsonian Institution, Washington, D.C. are abbreviated A.A.A.

LOUISE BOURGEOIS

Bloch, Susi. "An Interview with Louise Bourgeois," *Art Journal*, 35 (Summer 1976), pp. 370–73.

The Brooklyn Museum, New York. *Louise Bourgeois: Recent Work*. Exhibition catalogue, with text by Charlotta Kotik, 1993.

Kuspit, Donald. *Interview with Louise Bourgeois*. New York: Vintage Books, 1988.

The Museum of Modern Art, New York. *Louise Bourgeois*. Exhibition catalogue, with text by Deborah Wye, 1982.

Robert Miller Gallery, New York. *Louise Bourgeois Drawings*. Exhibition catalogue, with text by Louise Bourgeois and Robert Storr, 1988.

Storr, Robert. "Intimate Geometries: The Work and Life of Louise Bourgeois." *Art Press*, 175 (December 1992), pp. E1–E5.

DOROTHY DEHNER

Fortess, Karl. "Interview with Dorothy Dehner," February 15, 1973, audiotape. A.A.A.

The Jane Voorhees Zimmerli Art Museum, Rutgers, The State University of New Jersey, New Brunswick. *Dorothy Dehner and David Smith: Their Decades of Search and Fulfillment*. Exhibition catalogue, with text by Joan M. Marter and Judith McCandless, 1984.

Katonah Museum of Art, New York. *Dorothy Dehner: Sixty Years of Art*. Exhibition catalogue, with text by Joan M. Marter, 1993.

Krauss, Rosalind E. and Garnett McCoy. "Interview with Dorothy Dehner," December 1966, transcript. A.A.A.

Marter, Joan M. "Dorothy Dehner." *Woman's Art Journal* (Fall 1980/Winter 1981), pp. 47–50.

HERBERT FERBER

Ferber, Herbert. "Statement, The Ides of Art: The Attitudes of Ten Artists on Their Art and Contemporaneousness." *The Tiger's Eye*, 2 (December 1947), p. 44.

_____. "Statement, The Ides of Art: Fourteen Sculptors Write." *The Tiger's Eye*, 4 (June 15, 1948), pp. 75–76.

_____. "The New Sculpture: A Symposium," February 12, 1952, transcript, library. The Museum of Modern Art, New York.

Goossen, Eugene C. "Herbert Ferber." *Three American Sculptors: Ferber, Hare, Lassaw*. New York: Grove Press, 1959.

Museum of Fine Arts, Houston, Texas. *Herbert Ferber, Sculpture, Painting, Drawing: 1945–1980*. Exhibition catalogue, with text by William C. Agee, 1983.

Sandler, Irving. "Interviews with Herbert Ferber," April 22 and December 31, 1968; and January 6, 1969, transcript. A.A.A.

Tuchman, Phyllis. "Interview with Herbert Ferber," June 2, 1981, transcript. A.A.A.

Walker Art Center, Minneapolis, Minnesota. *The Sculpture of Herbert Ferber*. Exhibition catalogue, with text by Wayne V. Anderson, 1962.

SEYMOUR LIPTON

Elsen, Albert. "Seymour Lipton: Odyssey of the Unquiet Metaphor." *Art International*, 1 (February 1, 1961), pp. 38–44.

Fesci, Sevim. "Interview with Seymour Lipton," 1968, transcript. A.A.A.

Lipton, Seymour. "Some Notes on My Work." *Magazine of Art*, 40 (November 1947), p. 264.

_____. "The Web of the Unrhythmic." *The Tigers Eye*, 4 (June 15, 1948), p. 80.

_____. "Experience and Sculptural Form." *College Art Journal*, 9 (1949), pp . 52–54.

_____. "Statement." *12 Americans*. Museum of Modern Art, New York. Exhibition catalogue, 1956, p. 72.

National Collection of Fine Arts, Washington, D.C. *Seymour Lipton: Aspects of Sculpture*. Exhibition catalogue, with text by Harry Rand, 1979.

Seckler, Dorothy. "Interviews with Seymour Lipton," April 28 and May 20, 1964, transcript. A.A.A.

ISAMU NOGUCHI

Ashton, Dore. *Noguchi East and West*. New York: Alfred A. Knopf, 1992.

Cummings, Paul. "Interviews with Isamu Noguchi," November 7, 1973; December 10, 18, and 26, 1973, transcript. A.A.A.

Grove, Nancy, and Diane Botnick. *The Sculpture of Isamu Noguchi: A Catalogue Raisonné*. New York: Garland Publishing, 1980.

Noguchi, Isamu. "Statement." *The Tiger's Eye*, 4 (June 15, 1948), p. 81.

_____. "Meanings in Modern Sculpture." *Artnews*, 49 (March 1949), pp. 12–15, 55–56.

____. "Toward a Reintegration of the Arts." *College Art Journal*, 9 (Autumn 19 49), pp. 59–60.

____. *A Sculptor's World*. New York: Harper & Row, 1968.

Polcari, Stephen. "Martha Graham and Abstract Expressionism." *Smithsonian Studies in American Art*, 4 (Winter 1990), pp. 3–27.

Walker Art Center, Minneapolis, Minnesota. *Noguchi's Imaginary Landscapes*. Exhibition catalogue, with text by Martin Friedman, 1978.

Whitney Museum of American Art, New York. *Isamu Noguchi*. Exhibition catalogue, with text by John Gordon, 1968.

Theodore Roszak

Dreishpoon, Douglas. "Theodore J. Roszak (1907–1981): Painting and Sculpture." Ph.D. dissertation, City University of New York, 1993.

Elliott, James. "Interview with Theodore Roszak," February 13, 1956, transcript. A.A.A.

Marter, Joan M. *Theodore Roszak: The Drawings*. New York: The Drawings Society, Inc., 1992

Phillips, Dr. Harlan B. "Theodore Roszak Reminisces: As Recorded in Talks with Dr. Harlan B. Phillips," 1964, transcript. Theodore Roszak Estate.

Robinson, Joan Seeman. "The Sculpture of Theodore Roszak: 1932 1952." Ph.D. dissertation, Stanford University, 1979.

David Smith

Anthony d'Offay Gallery, London, England. *David Smith: Drawings of the Fifties*. Exhibition catalogue, with text by Jean Freas, 1988.

The Edmonton Art Gallery, Alberta. *David Smith The Formative Years: Sculpture and Drawings from the 1930s and 1940s*. Exhibition catalogue, with text by Karen Wilkin, 1981.

International Exhibitions Foundation, Washington, D.C. *The Drawings of David Smith*. Exhibition catalogue, with text by Trinkett Clark, 1985.

Kingsley, April. *The Turning Point: The Abstract Expressionists and the Transformation of American Art*. New York: Simon & Schuster, 1992.

Knoedler & Company, New York. *David Smith Nudes: Drawings and Paintings from 1927–1964*. Exhibition catalogue, with text by Paul Cummings, 1990.

Krauss, Rosalind E. *Terminal Iron Works: The Sculpture of David Smith*. Cambridge, Massachusetts: M.I.T. Press, 1971.

____. *The Sculpture of David Smith: A Catalogue Raisonné*. New York: Garland Publishing, 1977.

McCoy, Garnett, ed. *David Smith*. New York: Praeger Publishers, Inc., 1973.

Salander-O'Reilly Galleries, Inc., New York. *David Smith: Works on Paper 1953–1961*. Exhibition catalogue, with text by Phyllis Tuchman, 1991.

Smith, David. "The Golden Eagle—a Recital." *The Tiger's Eye*, 4 (June 15, 1948), p. 81.

____. "The New Sculpture: A Symposium," February 12, 1952, transcript, library. The Museum of Modern Art, New York.

____. "The Language is Image." *Arts and Architecture*, 69 (February 1952), pp. 20–21.

____. "Thoughts on Sculpture." *College Art Journal*, 13 (Winter 1954), pp. 97–100.

____. "Second Thoughts on Sculpture." *College Art Journal*, 13 (Spring 1954), pp. 203–207.

Storm King Art Center, Mountainville, New York. *David Smith Drawings for Sculpture: 1954–1964*. Exhibition catalogue, 1982.

Whitney Museum of American Art, New York. *David Smith: The Drawings*. Exhibition catalogue, with text by Paul Cummings, 1979.

Wilkin, Karen. *David Smith*. New York: Abbeville Press, 1984.

____. "The Drawings of David Smith." *The New Criterion*, 8 (March 1990), pp. 13–17.

General Sources

Albright-Knox Art Gallery, Buffalo, New York. *Abstract Expressionism: The Critical Developments*. Exhibition catalogue, ed. Michael Auping, with essays by Ann Gibson, Donald Kuspit, Michael Leja, Marcelin Pleynet, Richard Shiff, and David Sylvester.

Alloway, Lawrence. "The Biomorphic Forties." *Artforum* (September 1965), pp. 18–22.

Anderson, Wayne. "The Fifties." *Artforum*, 5 (June 1967), pp. 60–67.

Gibson, Ann Eden. "Theory Undeclared: Avant-Garde Magazines as a Guide to Abstract Expressionist Images and Ideas." Ph.D. dissertation, University of Delaware, 1984, pp. 200–23.

Krauss, Rosalind E. *Passages in Modern Sculpture*. Cambridge, Massachusetts: M.I.T. Press, 1977, chapters 4–5.

Leja, Michael. *Reframing Abstract Expressionism: Subjectivity and Painting in the 1940s*. New Haven: Yale University Press, 1993.

Metropolitan Museum of Art, New York. *Abstract Expressionism: Works on Paper*. Exhibition catalogue, with text by Lisa Mintz Messinger, 1992.

Polcari, Stephen. *Abstract Expressionism and the Modern Experience*. New York: Cambridge University Press, 1991.

Whitney Museum of American Art, New York. *The Third Dimension*. Exhibition catalogue, with text by Lisa Phillips, 1984.

Library of Congress
Card Catalogue Number: 93-61744
ISBN 1-878293-07-9

Designed by Bob Hellier
Edited by Sheila Schwartz
Printed by Rinaldi Printing

All photographs by Tom Kettner,
with the following exceptions:

Pat Bazelon: Figs. 7, 9

Prudence Cumming Associates Limited,
London, England: Fig. 8

Marc Fournier: Pl. II; Figs. 11, 12, 13, 14, 15, 16

Kerry Schess: Pls. III, IV;
Figs. 17, 18, 19, 20, 21, 22, 23, 24, 28, 29, 30

Courtesy The Museum of Modern Art, New York: Fig. 25

Helga Photo Studio, Upper
Montclair, New Jersey: Figs. 26, 27

Kevin Noble: Figs. 31, 32, 33, 34

Courtesy Robert Miller Gallery, New York: Pl. VI;
Figs. 38, 39, 40, 41, 42, 43, 44

Geoffrey Clements: Fig. 46